IMAGES
of America

AFRICAN AMERICANS
OF TAMPA

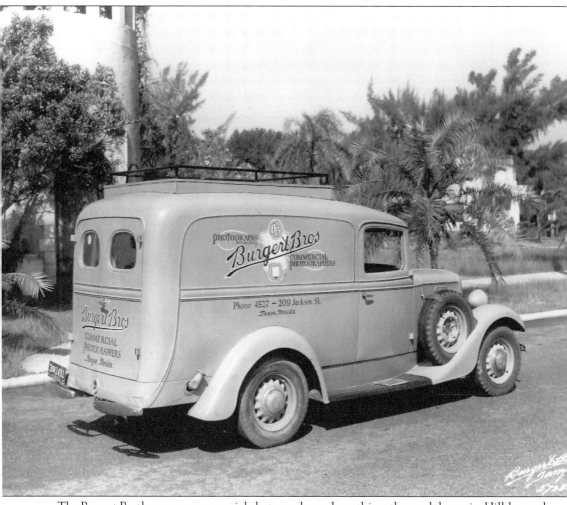

The Burgert Brothers were commercial photographers whom this author and the entire Hillsborough County community have to thank for preserving a half century of local history. (Courtesy of the Tampa Hillsborough County Public Library.)

ON THE COVER: Majorettes were a standard and valued section of the typical marching band. Swirling, spinning, and synchronized baton maneuvers were required skills for these young ladies of Middleton High School. Their beautiful smiles, seen here as they pose on October 11, 1954, made them a wonderful example of an era that needs to be remembered. Pictured on the front cover are, from left to right, (standing) unidentified, Jean Sheard, and Bertha Moore Smith; (kneeling) Vivian Yeoman. Phyllis Green Lee is on the back cover. (Courtesy of the Tampa Hillsborough County Public Library.)

IMAGES
of America

AFRICAN AMERICANS OF TAMPA

Ersula Knox Odom

ARCADIA
PUBLISHING

Published by Arcadia Publishing
Charleston, South Carolina

Printed in the United States of America

Library of Congress Control Number: 2014936972

For all general information, please contact Arcadia Publishing:
Telephone 843-853-2070
Fax 843-853-0044
E-mail sales@arcadiapublishing.com
For customer service and orders:
Toll-Free 1-888-313-2665

Visit us on the Internet at www.arcadiapublishing.com

This book is dedicated to those who shared their connections and asked, "Did you talk to . . . ?" and then picked up their telephones and called that person. It is also dedicated to those persons who allowed the author in and walked down memory lane with her, especially the late attorney Frank S. Stewart.

CONTENTS

ACKNOWLEDGMENTS

I would like to give a heartfelt thank-you to the Hillsborough County Public Library staff, especially those employees of the John Germany Genealogy Department. Their assistance with my enthusiastic search of the Burgert Brothers photography collection is most appreciated.

A special thanks to the Tampa Bay Black Heritage Festival, Richedean Hills-Ackbar, Frank S. Stewart, Doris Ross Reddick, Dr. Walter L. Smith, Ethel Johnson of the *Weekly Challenger News*, Coach Billy and Dorothye Reed, Delano S. Stewart, Tanya Akbar, Myron Jackson, Hewitt Smith and Mrs. Kennedy, Dianne Speights, Fred Hearns, the Tampa chapter of the Afro-American Historical and Genealogical Society, Warren H. Dawson, the Florida Memorial Carrie Meeks History Museum on the Florida A&M University campus, George Robinson, Richard Robinson, Phyllis McEwen, Osborne Odom, Elaine Harris, the Reynolds family, Michael McNeal, Justine Anderson, Sen. Arthenia Joyner, and Harold Clark.

Throughout this book, certain images will be followed by the following credits: Tampa Hillsborough County Public Library (HCPL) or University of South Florida Special Collections (USF).

INTRODUCTION

Tampa's African American history began with names that may never be known. What is known is that there were many who came to Tampa to escape slavery. Some joined and lived with Native Americans. Many arrived in Tampa as Cubans. Some arrived as free men and women. Some were enslaved. Many arrived as soldiers armed and ready to fight for and defend freedom. This book preserves some of the names, faces, places, and events and begins to fill some missing pieces.

Indians and African Americans were united by a common enemy. The enemy wanted to take one group's land and the other group's freedom, and this fostered a natural alliance between the two. This alliance is mostly documented in the history of the Seminole Wars.

Tampa's history from 1860 through 1881 is what the author considers "the silent years" because a great deal of what happened for African Americans in Tampa during that time still does not have a strong voice in history. The Civil War, emancipation, and Reconstruction occurred during these years.

In June 1862, during the Civil War, when incorporated Tampa was just seven years old, Union gunboats arrived at Fort Brooke, and those on guard refused to surrender to the Federal commander. A second attempt to capture Tampa occurred on October 17, 1863. Two ships arrived on a mission to stop the blockade-running operations of Capt. James McKay. Two McKay vessels loaded with cotton and ready for export were burned. Confederates caught up with the Yankees at Ballast Point. Nine people were killed and many more injured. There was no clear victory. The adage that there are two sides to every story rings true when one considers the plaque commemorating the cannon's last stand. A portion of it reads, "These 24 pound shot size cannon were part of a battery of three placed in Fort Brooke during the War Between the States. They and two 6 pound shot size rifled cannon successfully defended Tampa until May 5, 1864. On that date, federal troops, composed of elements of the 2nd US Colored Regiment, the 2nd Florida Calvary, and the US Navy, captured the town and fort by surprise. The 24 pounders were disabled by breaking off a trunnion and destroying their barbette carriages. The 6 pounders were then taken to Key West." Fort Brooke surrendered without a single shot. The fort was destroyed, and the cannons were thrown in the bay. To some, May 5, 1864, was the last day the cannons defended Tampa. To African Americans, May 6, 1864, represents the first day of freedom, even if was not known. The fact that a "colored regiment" was involved is hidden in plain sight behind the title "The Spanish Fort." The Friends of Plant Park must be celebrated for including this history in 2008.

As for African Americans' role in the Spanish-American War, consider that on July 1, 1898, four "colored regiments," along with Teddy Roosevelt and his Rough Riders, were a part of a 15,000-troop deployment to Cuba. When the United States began their evacuation, they kept the African American Ninth Infantry Regiment in Cuba to support the occupation. The rationale for this was because of their race, and because of the fact that many African American volunteers were from Southern states, meaning they would be "immune" to yellow fever. They were not immune.

Whether they were employed by others or functioned as business owners, African Americans were a part of the very foundation upon which Tampa was built. It was by their hands and their sweat that Tampa emerged from a swamp into the home of world-renowned citrus, shipping, fishing, and cigar industries.

In 1881, Henry B. Plant brought the railroad to Tampa, uniting water travel and shipping with land travel and freight. Tampa exploded, and the role of African Americans with it. According to the March 30, 1926, *Tampa Morning News*, Tampa's population grew from 94,743 in 1925 to 213,615 in 1930. Even though the role of African Americans was critical, Jim Crow laws suppressed and silenced cross-cultural celebration of this importance; however, celebration happened in the African American community. Success happened. This book is a glimpse into the world as it was primarily before desegregation. Central Avenue's business and social area, the Urban League, unions, men's and women's clubs, fraternities and sororities, schools, and churches were at the core of this success, and they are the subjects of this book.

One fascinating example of how one person can create an industry and change a city's destiny is that of Dr. Odet Philippi. He purchased a black woman who was a highly skilled cigar maker and brought her to Tampa, where she made cigars for his salon patrons. She made the first cigars in the area, which came to be known as the "Cigar City."

There will be an abundance of illustrations associated with the education and religion of Tampa's African American community. With education denied to African Americans for a couple of centuries, these pillars became the framework for social, spiritual, and economic development.

The stories told in this book were chosen as dictated by the photographs discovered or shared by those persons with Tampa roots. Many of the persons shown in these images are the ancestors of current local and national leaders. When these connections are known, they are noted. There are some well-known citizens and some who are not so well known. They are all designed to be thought provoking, educational, and entertaining.

Hopefully, this book will open hearts and minds to ask, "What's the rest of the story?"—and then seek to uncover it. There are so many untold African American stories, and many who are aware of them are quiet mainly because no one has asked them to share.

One

EARLY DAYS

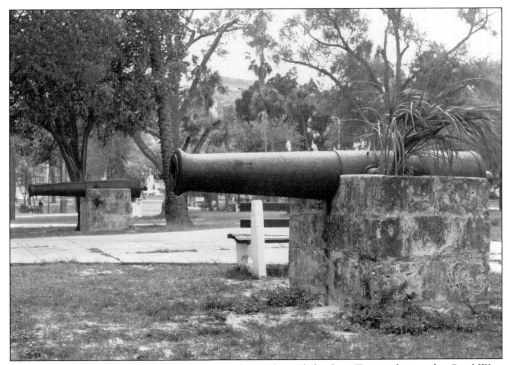

These cannons were preserved to celebrate their role in defending Tampa during the Civil War. They represent the end of the war and "Southern heritage" for some. They represent the end of slavery for African Americans. (Tony Pizzo Collection, USF.)

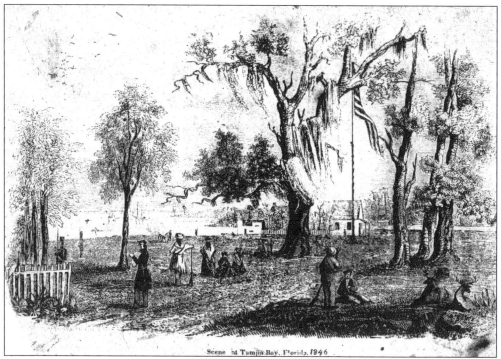

This illustration of 1847 Tampa Bay depicts the rural and agricultural nature of the area. Less than 50 years later, Tampa Bay would be a booming shipping, cigar, and vacation magnet on the verge of a construction explosion. (HCPL.)

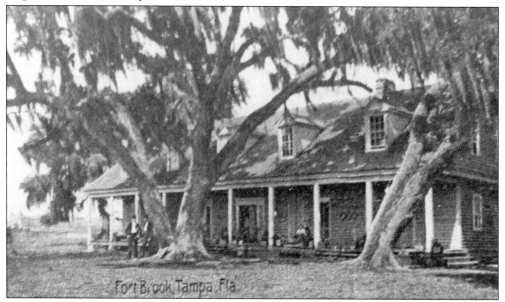

In 1824, Fort Brooke was built to defend against frequent invasions via the Gulf of Mexico. The Tampa Convention Center now sits where Fort Brooke and the surrounding camps once stood. Today, the Fort Brooke Parking Garage bears the name and commemorates the historic site. The garage connects several prominent office buildings and a hotel in thriving downtown Tampa. (USF.)

As part of a network of army forts that were established throughout the state of Florida, Fort Brooke was built in 1824 and named for its commander, Col. George Mercer Brooke. Fort Brooke and the fishing and farming village that developed around it were eventually called by the area's Indian name, Tampa. Tampa was incorporated in 1855. (USF.)

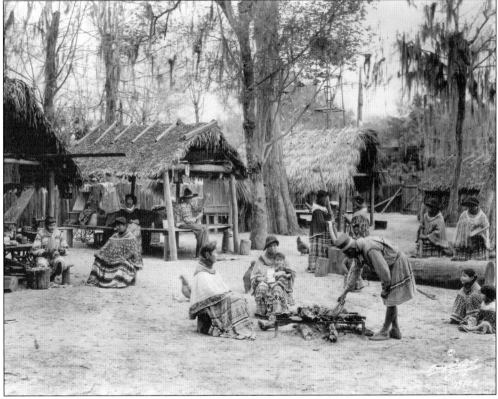

During the Seminole Wars, Captain Mix described the Seminoles as "a mixed race and complexions of every hue from jet black to Indian brown to quite fair." Thus is the story of African Americans. (USF.)

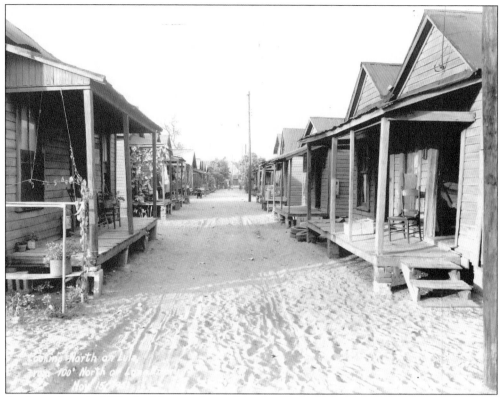

As shown here in 1951, the "shotgun houses" in the "Scrubs" were houses designated for black people. They were called shotgun houses because one could shoot in the front door and the shot would go out the back without hitting anything. The name "Scrubs" was used to describe the visibility of the clothes-washing service that was commonplace. (HCPL.)

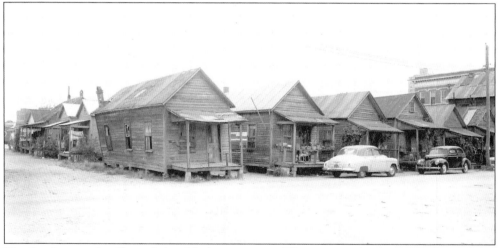

The Scrubs served as Tampa's first black community. The area was later converted to Central Park Village and eventually demolished. Coach Billy Reed told of being able to jump from porch to porch and move through the length of the row. A portion of Meacham High School is showing in the upper-right corner of this image. The Scrubs was located on Nebraska Avenue and Constant Street. (HCPL.)

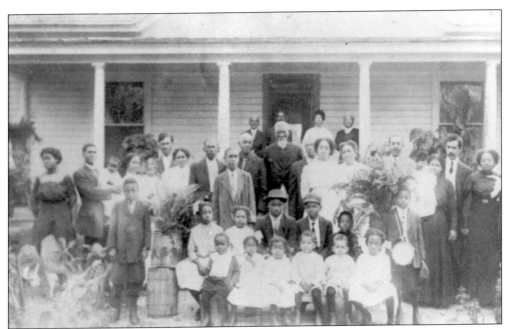

Following the Civil War, some African American families, and their housing, were above average. This was the case for the Armwood family, who arrived in the Tampa Bay area in 1866. The Armwoods played a key role in building Tampa by being successful businesspeople, civil servicemen, and brilliant educators. (USF.)

These photographs of the Scrubs were a part of the "Study of Negro Life in Tampa" commissioned by Benjamin Mays and documented in the *Raper Report*, published in 1927 by J.H. McGraw with the cooperation of the Tampa Urban League and the Tampa Welfare League. Outdoor toilets were a reality, even in Tampa. Trucks combed the streets weekly, picking up "honey pots" for disposal. (HCPL.)

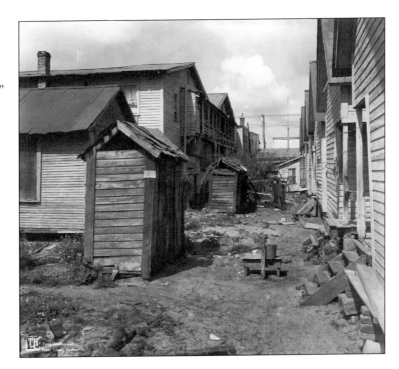

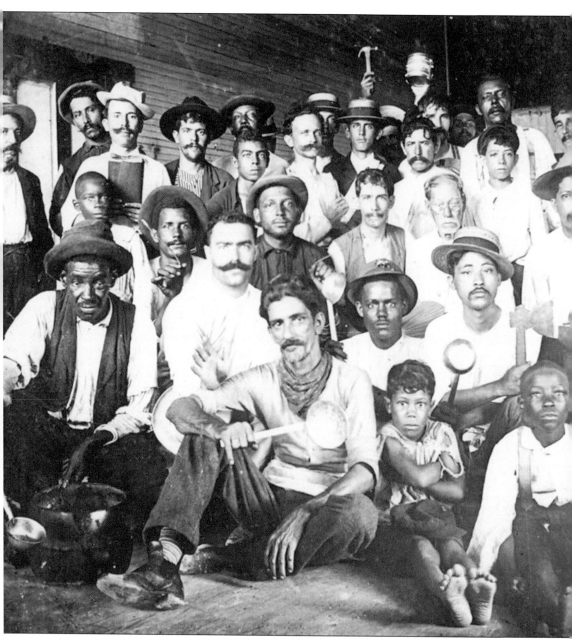

Upon arrival, Cuban immigrants did not separate along racial lines, which presented problems for the post-1898 Plessy v. Ferguson segregated South. In the late 1800s and early 1900s, West Tampa and Ybor City were known as "Cigar Cities" and were alive with cultural diversity. The ladles depict the men's role in providing soup kitchens to feed striking cigar workers in 1899. Jim Crow laws ultimately forced separation. (USF.)

Two

BUILDING TAMPA

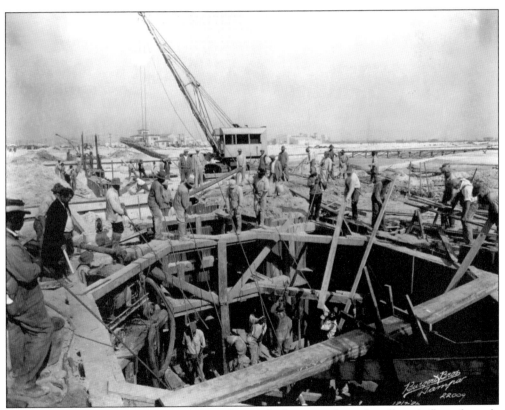

With the massive amount of construction that took place in order to handle to influx of people into Tampa, men did the work that machines do today. In this December 8, 1926, photograph, the workers are creating a drainage system on Davis Island. This drainage system was critical to the island's very existence as a viable area for housing and the municipal airport that was eventually developed there. (HCPL.)

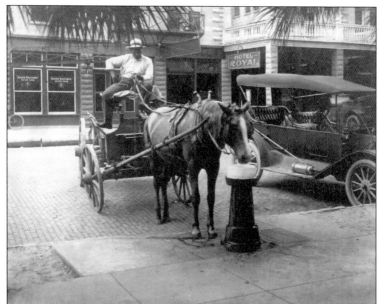

In this 1912 photograph, an African American driver is seated in a wagon as his horse drinks from a water fountain on Madison Street in Front of the Hillsborough County Courthouse. Today, it is just over 100 years since horses were the main form of transportation in the downtown area. (HCPL.)

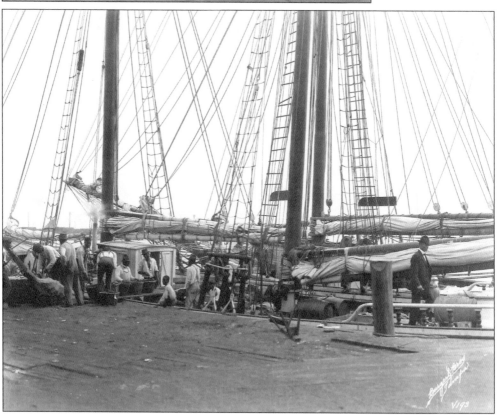

In this December 1919 photograph, a child can be seen in the midst of the dock's loading and unloading activity. It is not known if he is working or accompanying an adult. It is known that countless young sons and daughters were college educated with the wages earned by dockworkers in Tampa. (HCPL.)

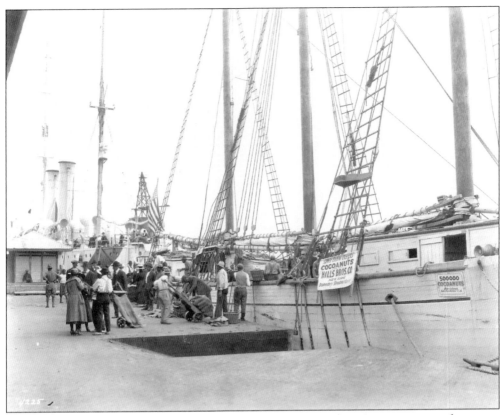

Workers in Tampa's busy port are shown here unloading Hills Brothers Company cargo of coconuts from the Gulf & Southern Steamship Company in February 1919. The sign has an interesting spelling of coconuts: "cocoanuts." The Hills Brothers Company operated out of Houston and shipped between New Orleans, Tampa, Miami, Jacksonville, Savannah, and Charleston. (HCPL.)

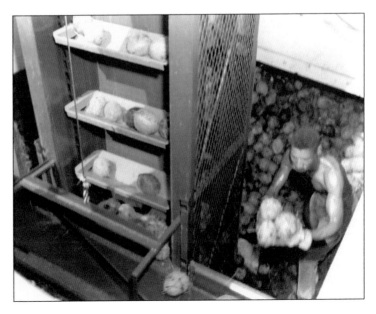

Workers of the time made a living doing jobs under unimaginable conditions by current standards. This worker, in a ship's pit, is unloading, sorting, selecting, and placing coconuts on a conveyor belt for processing. The sweat on his arms suggests how labor intensive and hot the environment was. (HCPL.)

Dr. Odet Phillipi represented himself as French (while recorded descriptions indicate he may have been of African descent) and purchased an African American woman and brought her to Tampa. She was a highly skilled cigar maker who made the first cigars in Tampa. Phillipi Park in Clearwater is named for him. (HCPL.)

Shown here is a driver for Poinsettia Ice Cream Company in front of its plant at 531 Central Avenue. The company was founded in 1898 by W.J. Barritt of Tampa, merged with the T.H. Rifley Company in 1919, and affiliated with the Borden Company in 1943. Borden's most recognized image was Elsie the cow. (HCPL.)

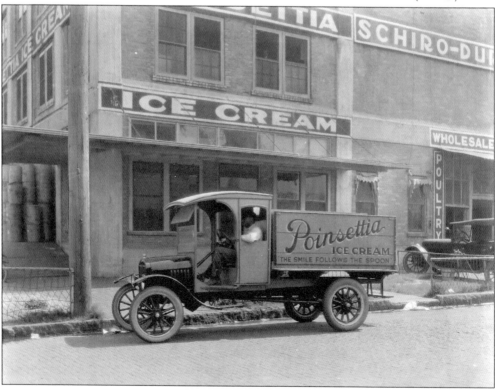

The Tampa Urban League staff is shown here preparing toys for distressed children during the Depression. A great number of these toys were made with slats from the abundance of discarded shipping crates, which was a wonderful reuse of materials. (HCPL.)

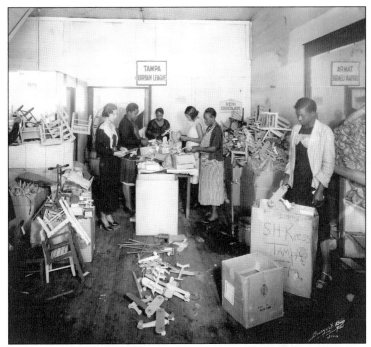

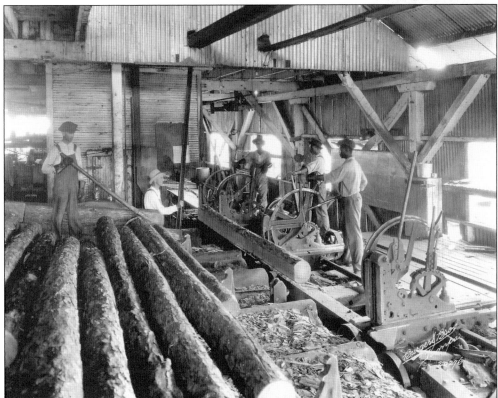

Trees have been harvested and are being cut into lumber by these workers. During this time, it was not uncommon for homes to be built from a single tree. (HCPL.)

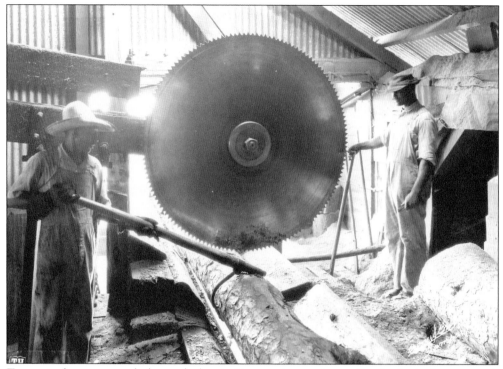

To sustain the great growth that took place in Tampa, a large volume of lumber had to be processed. This 1926 photograph illustrates the use of a circular saw as part of the production process of the time. Once processed, it was used locally and shipped to national and international destinations from Tampa's port. (HCPL.)

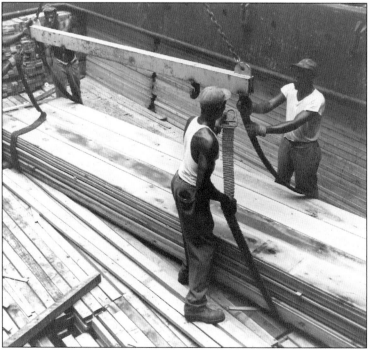

The huge demand for lumber for domestic and commercial building created a considerable labor requirement. These workers are loading lumber onto a ship for transport. (HCPL.)

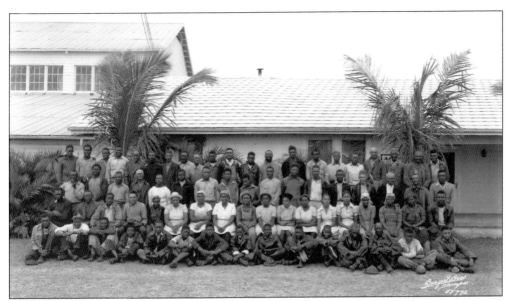

These A&W Bulb Company agricultural workers from the Fort Myers area are shown here because of the role gladiolus played in the Tampa Bay area. They were used for resale by individuals and African American churches. (HCPL.)

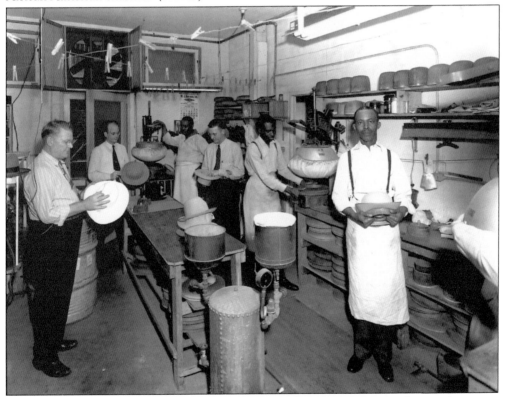

Workers at Adams City Hatters, located at 620 Tampa Street, are posing in their workroom on January 15, 1947. Hats were a fashion statement, and they drove demand for the kind of systems shown in the Adams City Hatters workshop. (HCPL.)

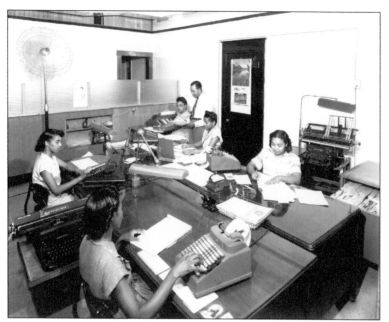

In the pre-computer era, workers at companies like Central Life Insurance Company had to form typing pools in order to capture sales and report commissions. This group is seen at work on August 14, 1951. (HCPL.)

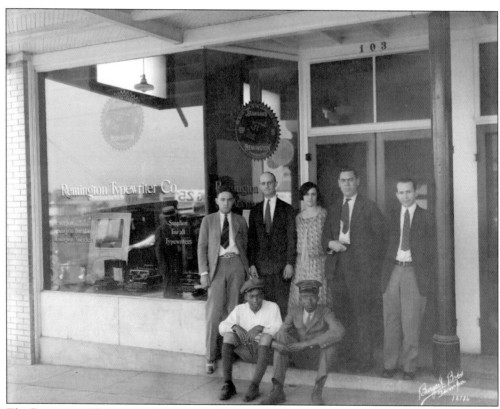

The Remington Typewriter Company staff posed for this photograph on April 16, 1926, in front of their office at 103 Parker Street. (HCPL.)

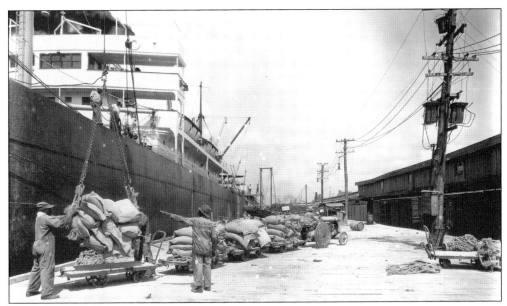

Stevedores can be seen loading cargo onto a large ship. These workers were also known as dockworkers, dockers, dock laborers, wharfies, and longshoremen. All are relating to waterfront ship loading and unloading jobs. (HCPL.)

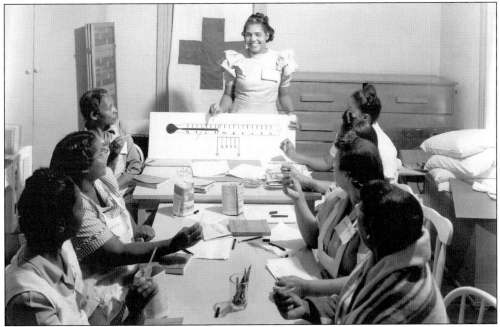

Helen Oneal Wilson was the wife of Sumner Wilson and the mother of Sandra Wilson. Sumner was the co-owner of Wilson's Funeral Home with his brother Clarence Wilson. It is currently owned and operated by Clarence's wife, Curtis. Helen was the first non-nurse African American certified in the county by the Red Cross; she then taught others. She also taught health at Middleton High School. Sandra was the first African American to earn a doctorate from the University of South Florida and was appointed by Gov. Lawton Chiles to the Hillsborough County Commission in 1994. (HCPL.)

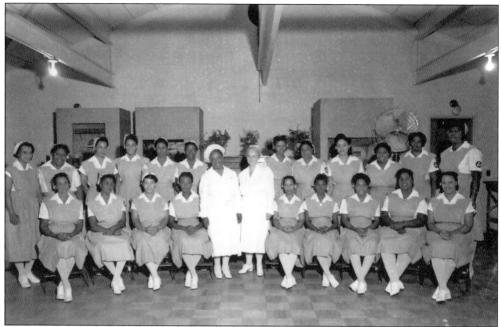

This graduating class had their ceremony at St. Paul African Methodist Episcopal (AME) Church. They could now look forward to days that included helping patients to wash and clean their teeth. The job meant helping with breakfast, blanket baths, and bed changing, as well as attending to pressure points, medicines, and dressings. (HCPL.)

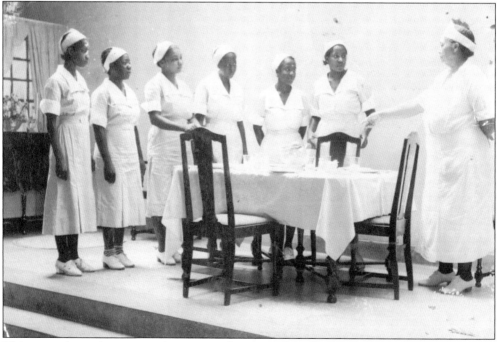

This scene shows domestic worker training being conducted. The students are learning proper table-setting techniques. This was one of the most accepted employment opportunities for young African American women at the time. (HCPL.)

Members of the American Red Cross are shown here in a meeting at the Tampa Urban League. Red Cross training was greatly needed during this time due to wars, fires, and hurricanes. (HCPL.)

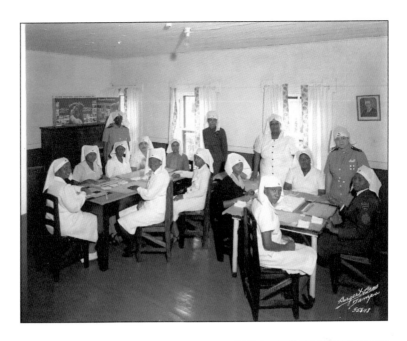

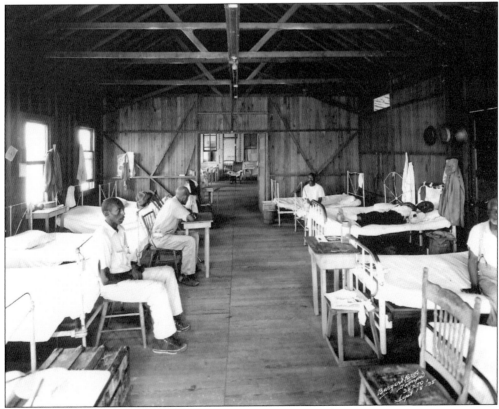

These men are being cared for in a ward at a Works Progress Administration county home in 1935. This facility was part of what developed into Padgett Nursing Home. The nursing home was founded by Susie Padgett. (HCPL.)

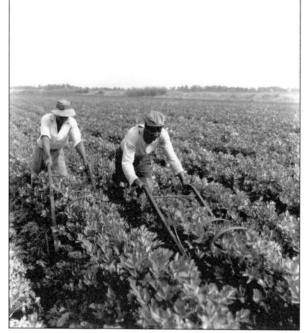

These farmworkers are cutting celery in a huge field in 1945. Florida's farm-favorable climate allowed multiple crops to be grown virtually year-round, making farming in the Tampa Bay area big business. (HCPL.)

In this March 5, 1946, photograph workers are harvesting gladiolus bulbs. A present-day farmer reflected on what a hard day's work this photograph suggests. These workers were out in the sun all day unprotected. The tractors were moving about the same pace as a person could walk. The man behind the tractor had to manually control the direction of the cutter blades and keep his balance while eating dust and bugs, like deer flies. (HCPL.)

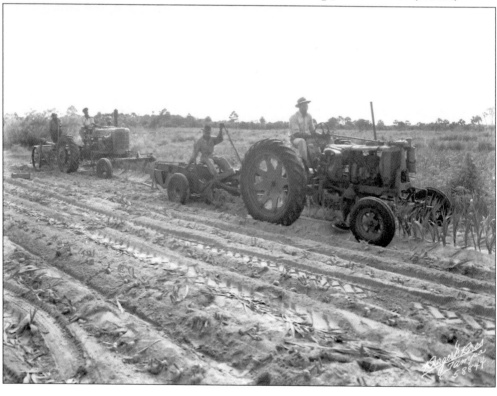

In 1940, Cecil Webb put together $20,000 in borrowed money and formed Dixie Lily Milling Co. of Tampa with the belief that "everybody got to have grits." The Webb fortune flourished. These workers are using scales to measure product for shipment from their location at 110 Nebraska Avenue. (HCPL.)

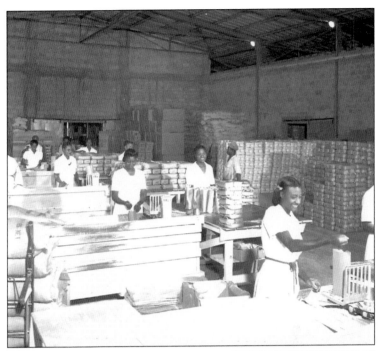

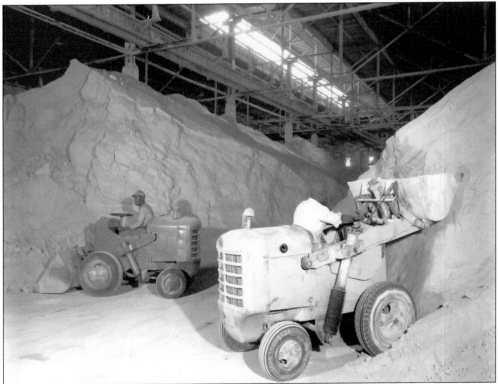

These workers are moving a massive volume of fertilizer for the Florida-Georgia Tractor Company in 1948. The fertilizer exploded yield and thus profits for growers. The bigger and faster the crops grew, the more demand there was for tractors for clearing and harvesting. (HCPL.)

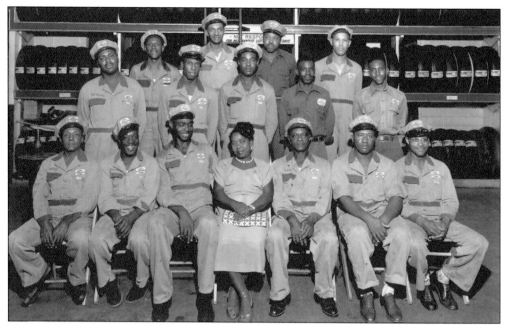

These African Americans were a part of a tire company's success story. In 1925, Howard Frankland bought a filling station in Tampa. He expanded the filling station to include a rubber-vulcanizing department and later added equipment that could recap rubber truck tires. Howard and his brother Frank Frankland built the Pioneer Tire Company, which flourished during World War II. Wartime rubber shortages motivated the company to make use of waste-rubber dust and combine it with cork to vulcanize the composition into rubber balls. They produced the rubber balls under the name Hofran in a new factory on Habana Avenue, manufacturing nearly 7,000 balls per day. They eventually sold the company to AMF and Voit. In 1957, Howard organized Rubber Products, Inc., to produce personalized rubber mats and a unique type of color-flecked floor tile called Tuflex. (HCPL.)

The staff of the Florida-Georgia Tractor Company poses for a photograph outside the building at 210–216 South Twelfth Street on September 25, 1959. (HCPL.)

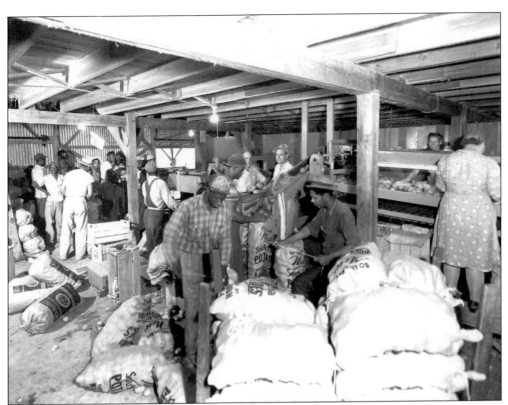

These workers are sorting and sacking potatoes in a food processing plant in March 1946. The bag labels suggest different grades of potatoes are being processed. One station is preparing "Red Nuggets." The Urban League used the slats from the empty crates like these to make toy planes or chairs for needy children. (HCPL.)

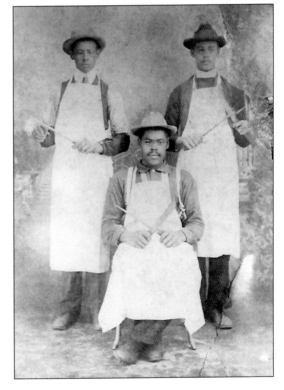

George Sheehy (left), Ben Sheehy (right), and their father, Joseph, were butchers in West Tampa from 1900 until about 1945. Joseph's grandson Dr. Paul Sheehy Jr. is a successful podiatrist. Sheehy Elementary, on Fortieth Street, is named in Dr. Paul Sheehy Sr.'s honor. (Courtesy of Dr. Paul Sheehy Jr.)

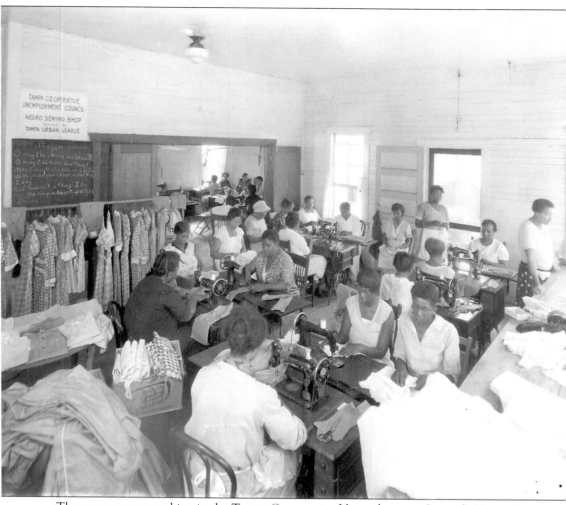

These women are working in the Tampa Cooperative Unemployment Council's Negro Sewing Shop in 1932. The dresses were made in bulk from a limited number of fabric designs, thus making them highly identifiable and known to some as "relief dresses." The dresses were created for those in need of financial relief. (HCPL.)

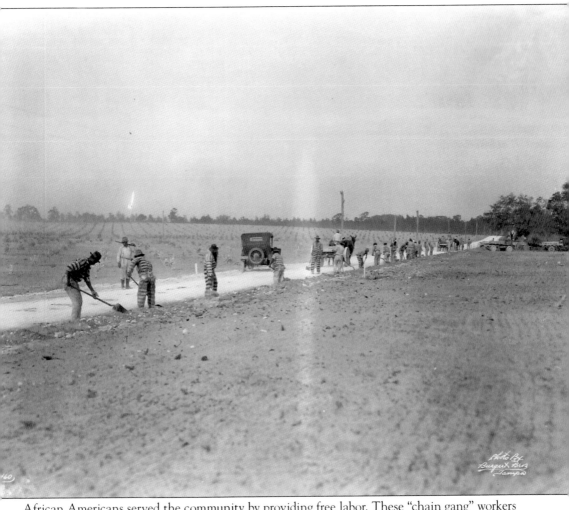

African Americans served the community by providing free labor. These "chain gang" workers were often incarcerated with questionable charges. Due to Jim Crow laws, an African American could be jailed for vagrancy if he could not prove he had a job. (HCPL.)

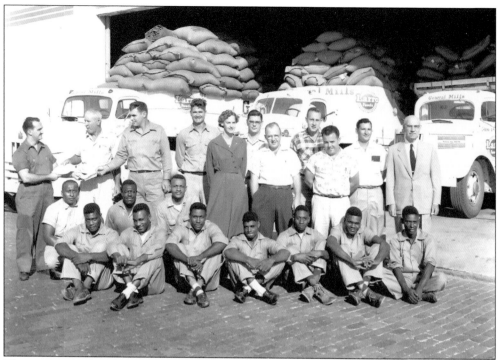

The employees of General Mills posed for this company photograph on October 29, 1956, at their location at 711 West Cass Street. (HCPL.)

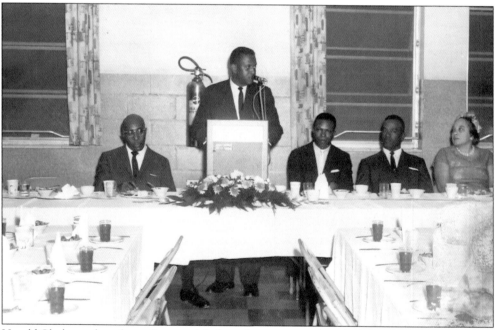

Harold Clark stands at the podium, and A. Leon Lowry is seated on the left. These two individuals were powerful forces in initiating changes to the Hillsborough County school system. Lowry became the first African American to serve on and chair the Hillsborough County School Board. (Courtesy of Harold Clark.)

Three

SEEKING EQUALITY

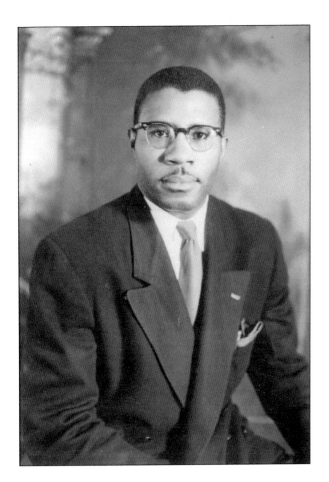

Robert W. "Bob" Saunders Sr., a
Tampa native, was born in 1921.
Following Harry and Harriett
T. Moores' murders in 1951,
Saunders served as Florida's
National Association for the
Advancement of Colored People's
(NAACP) field secretary and
directed Florida's NAACP civil
rights campaigns from his Tampa
office. Saunders worked in an
equal opportunity administrative
position for the federal government
in Atlanta. He returned to Tampa
as Hillsborough County's equal
opportunity administrator. The
Robert W. Saunders Library, at
1505 North Nebraska Avenue,
is currently being rebuilt into
a new, $7.8 million, 30,000-
square-foot facility. (USF.)

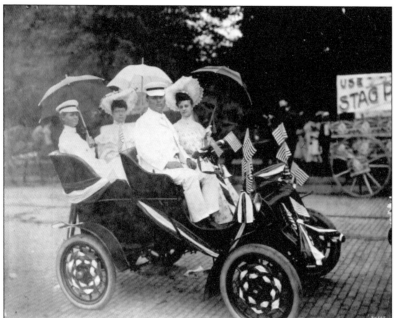

This group is riding in Tampa's first Gasparilla parade. The celebration is said to honor the fictional invasion of Jose Gaspar, a notorious pirate. This first parade took place on May 4, 1904, two days short of the 40th anniversary of the real invasion by the Union army on May 6, 1864. (HCPL.)

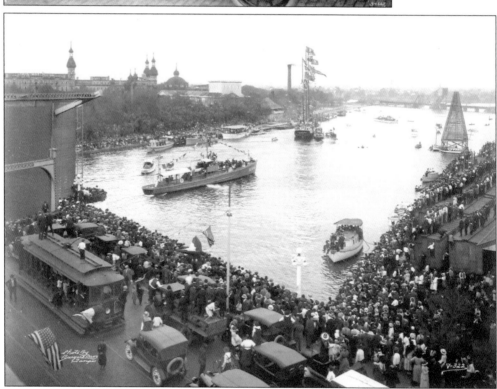

The Gasparilla invasion begins with the mayor of Tampa surrendering the keys to the city to a notorious pirate that entered the city via the bay and the Hillsborough River. It took a major challenge by attorney Warren Dawson in 1994 that threatened to end the celebration entirely before African Americans were allowed to board a float and ride in the annual parade that follows the invasion. (HCPL.)

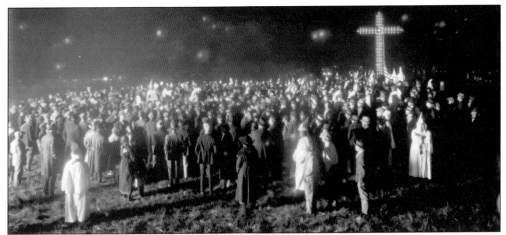

In 1923, a Ku Klux Klan rally took place in Lakeland, within 30 minutes of downtown Tampa. This organization's call to action was to promote "white supremacy" and force racial separation and cultural, political, and social suppression. This was done with hatred, intimidation, violence, destruction of property, and murder. At the time, some of these hooded individuals were in positions to make and enforce laws to implement their mission. (HCPL.)

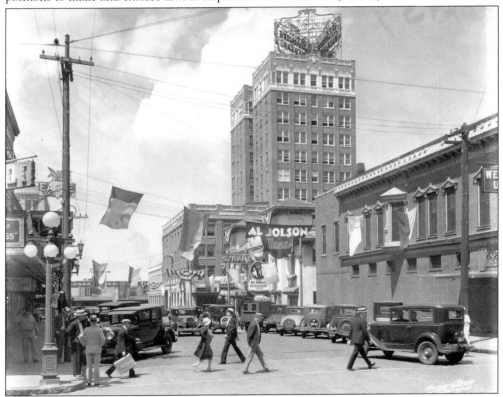

Black-faced performer Al Jolson historically drew hatred for promoting racist and negative African American imagery. Research suggests he was more complicated than what is believed. He is said to have had many African American friends, and he even took deliberate steps to support anti-black discrimination on Broadway. This is a photograph of a 1930 Franklin Street showing of *Mammy*. (HCPL.)

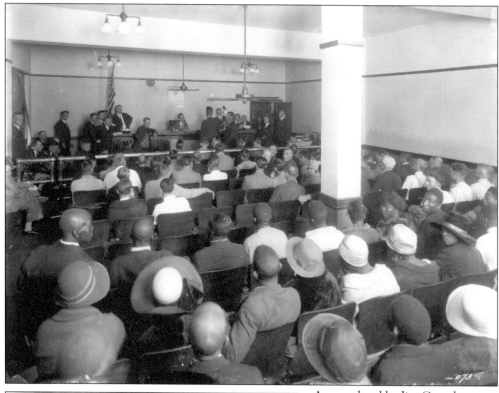

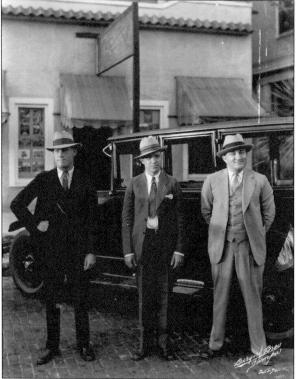

As mandated by Jim Crow laws, blacks and whites could not sit together on November 28, 1927, for the "Key Club" case, brought before Judge Leo Stalnaker. This was a high-profile case where a private club accessed only by "prominent" members with a special "key." With a key provided by an unhappy wife, the club was raided, a movie film was said to be recorded of the raid, a bartender and three Negro helpers (even though this was not a Negro-owned business) arrested, and liquor confiscated. All was done for Judge Stalnaker to "teach a moral lesson." (HCPL.)

Judge Leo Stalnaker is seen here on November 8, 1927, standing between two gentlemen in front of an automobile. (HCPL.)

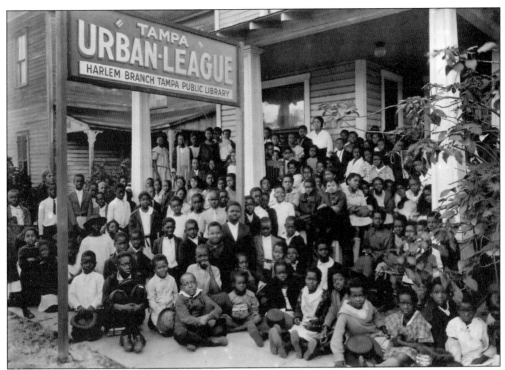

The Harlem Library moved to the Urban League location in July 1923. It originated at the Harlem Academy in 1919 and was closed in 1968, when the main library opened on Ashley Street. (HCPL.)

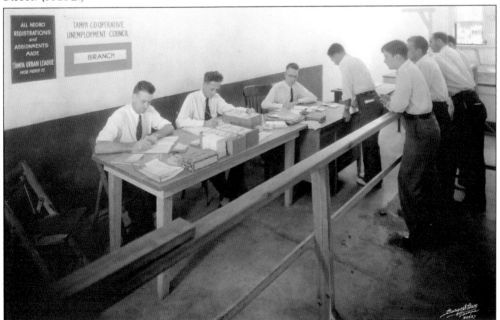

The sign at this Tampa Cooperative Unemployment Council branch is posted to inform Negroes that they will not be served at this location; however, they would be served at the Tampa Urban League at 1602 Pierce Street. (HCPL.)

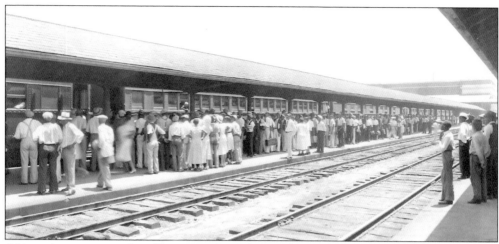

African American men from Tampa are shown leaving from Union Station for Emergency Relief Council forest camp on June 5, 1933. This was just three months after the newly inaugurated Pres. Franklin Roosevelt initiated his New Deal to battle the effects of the Great Depression in May 1933. The policy applied when private industry was unable to absorb the available workforce, at which point the government took on the responsibility of providing jobs. If local governments were not positioned to provide these jobs, then the federal government stepped in with work relief and jobs programs designed to overcome the economic devastation brought on by the Great Depression in the 1930s. These programs included the Temporary Emergency Relief Administration (TERA), the Federal Emergency Relief Administration (FERA), the Civil Works Administration (CWA), and the Works Progress Administration (WPA). (Both HCPL.)

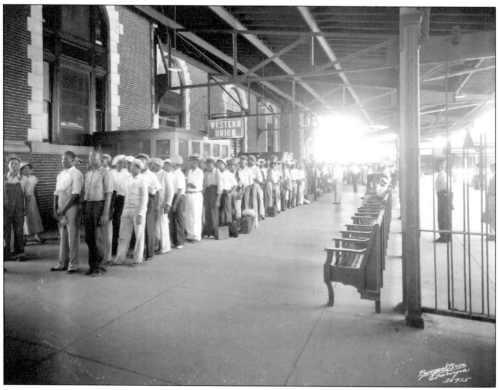

James Hammond is seen here with James C. Evans, civilian aid to the secretary of defense in Washington, DC, at Hammond's March 15, 1950, Reserve Officers' Training Corps (ROTC) graduation. Hammond credits Evans for saving his military career during a confrontation he had with a Jim Crow aggressor who refused to serve his three-bus integrated caravan of ROTC students. Evans argued against Hammond's dismissal for "disgracing the military" when he demanded equality. (Courtesy of James Hammond.)

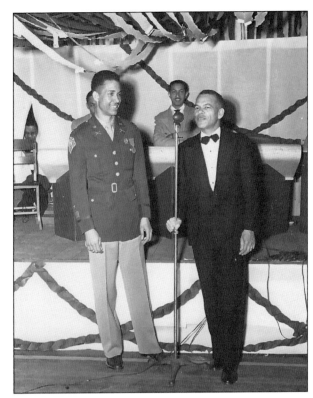

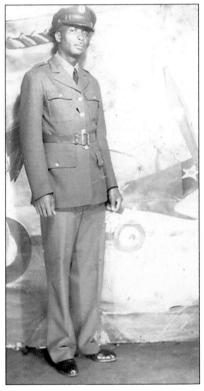

Ruben Reynolds entered the Army in 1941. Close examination of his shoes in this image reveals that he had mastered the spit shine. He moved to Tampa in 1939 from Blakely, Georgia, served in World War II, and then returned to Tampa and worked over 35 years as a longshoreman on the Tampa waterfront. He was known for crafting stories about lessons learned, education he had picked up from the soil of his agrarian community, respect for elders, honesty, and the value of hard and consistent work. He was member of the International Longshoremen's Association Local 1402 and the AFL-CIO. (Courtesy of Walter L. Smith Sr.)

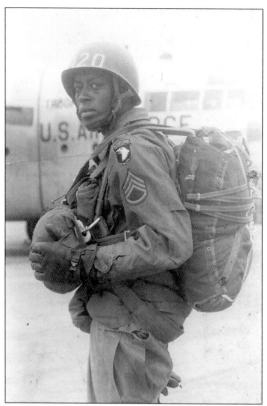

M.Sgt. Ralph Smith was a paratrooper in the 82nd Airborne during the Korean War. He also served in the Vietnam War and dedicated 30 years of service to the US military. (Courtesy of Walter L. Smith Sr.)

This is a group portrait of 1941 members of the Tampa Urban League. Seated on the far left is Marion Anderson, who was an active Alpha Kappa Alpha (AKA) member. J.W. "Billy Bow" Lockhart is sitting second from the right. Today, he has a school named for him. Standing third from the left is John Henry Evans, Andrew J. Ferrell is fifth from the left, and G.V. Stewart is standing on the far right. (HCPL.)

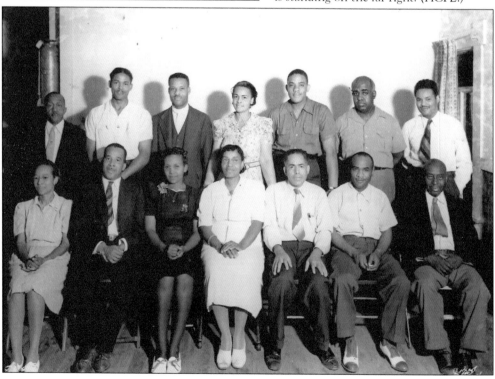

These are the 1945 officers of the Tampa Urban League, photographed in their office in January. The Urban League was the focal point for governmental directives for job training and relief for the needy. (HCPL.)

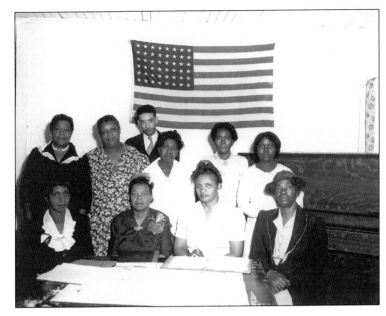

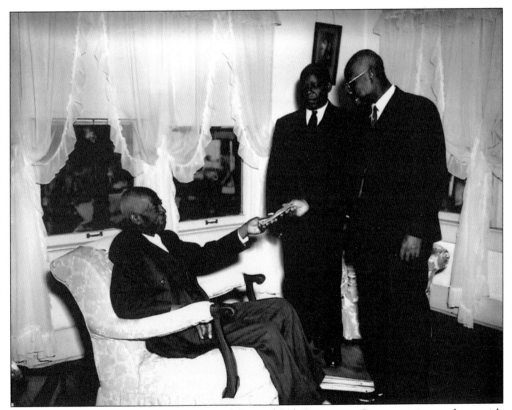

Rev. Marcellus D. Potter, vice president of Central Life Insurance Company, is seen here with Rev. D.L. Witherspoon and his guest at 1416 Orange Street on January 25, 1946. Potter was editor of the *Tampa Bulletin*, a black newspaper that operated from 1914 to 1959. The *Bulletin* was later acquired by C. Blythe Andrews and became part of the *Florida Sentinel*. (HCPL.)

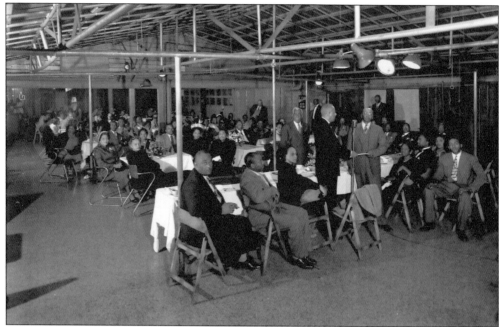

In 1950, Sanderson's Blue Room was host to the Brotherhood of Sleeping Car Porters banquet. A. Phillip Randolph is in the dark suit standing at the microphone. Perry Harvey Sr. is sitting in front on the far left, looking at the camera. Harvey was inspired by Randolph to form the dockworkers union, the International Longshoremen's Association No. 1402, in Tampa. (HCPL.)

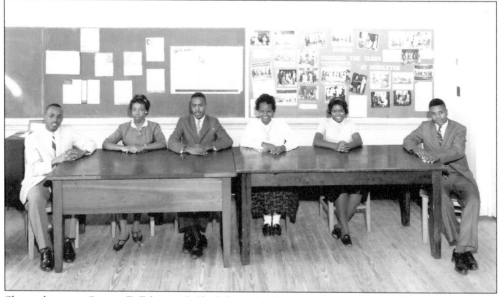

Shown here are George E. Edgecomb (far left) and other members of the Middleton High School Student Council. On January 29, 2004, the 13th Judicial Circuit Court dedicated the George E. Edgecomb Courthouse in honor of Hillsborough County's first African American judge. The Honorable George E. Edgecomb was sworn in as a county judge on August 13, 1973. He was also the first African American chief assistant county solicitor and Hillsborough County's first African American assistant state's attorney. (HCPL.)

Shown here are Nathal Jenkins (left) and Frank Gray, who both served in World War II. (Courtesy of Richedean Hills-Ackbar.)

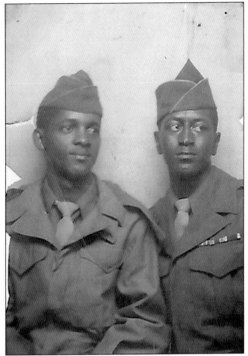

An ROTC group and young women celebrated on December 28, 1950, at the Harrison Street Recreation Center. The ROTC began when Pres. Woodrow Wilson signed the National Defense Act of 1916. The goal was to make the best military officers in the world and motivate young people to be better citizens. (HCPL.)

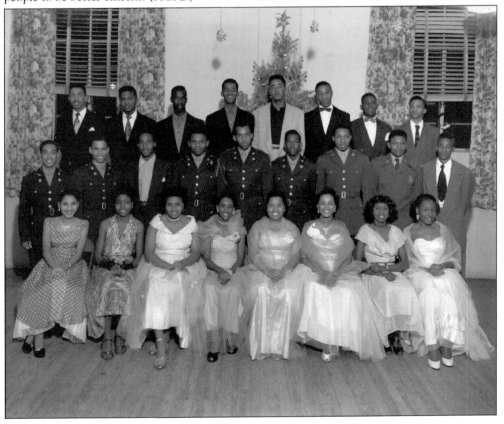

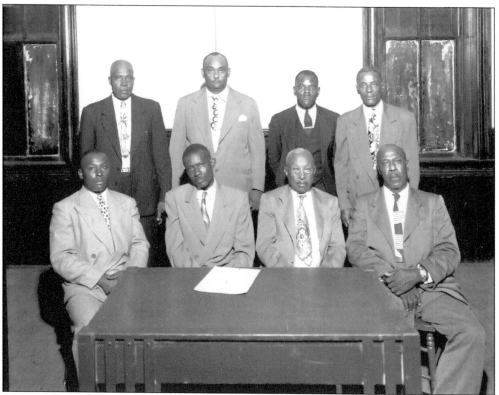

This is a 1952 International Longshoremen's Association meeting at the Odd Fellows Hall on Scott Street. Perry Harvey Sr., standing second from the left, led the dockworkers' union for more than 30 years. Today, Perry C. Harvey Park, which was named in his honor, faces what was Central Avenue. His son Perry Harvey Jr. became Tampa's first African American Hillsborough County commissioner. (HCPL.)

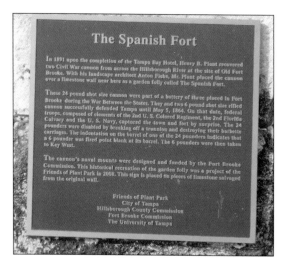

"The Spanish Fort" plaque on the University of Tampa's campus actually documents the May 5–6, 1864, role of the "federal troops, composed of elements of the 2nd US Colored Regiment" involvement in capturing Tampa and bringing freedom to African Americans; 101 years to the day later, on May 6, 1965, fair treatment was still an issue. James A. Hammond, Hazel Gibson, and NAACP attorney Francisco Rodriguez won a lawsuit against UT for refusing to admit Hammond and Gibson as African Americans. UT admitted its first African Americans within two years and the decision was reversed. (Author.)

Warren Hope Dawson (far right) started life singing gospel with his mother and brother and grew up to be a lawyer. He became president of the National Bar Association and served as the legal defense attorney for the NAACP through Tampa's desegregation years. Also shown are his brother Japhus and his mother, Naomi. (Courtesy of Warren H. Dawson.)

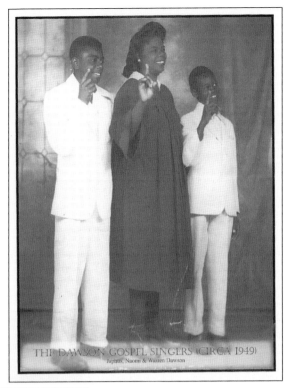

THE DAWSON GOSPEL SINGERS (CIRCA 1949)
Japhus, Naomi & Warren Dawson

Sam Philmore was the first African American police officer in Tampa to rise above the rank of patrolman. Philmore retired as a sergeant. He achieved a black belt in Judo. He patrolled Central Avenue from Scott Street to Cass Street. At one time, the only people an African American policeman could arrest were African Americans. Philmore was also the resource officer at Horace Mann Junior High School and the father of Mary Martin. (Courtesy of Justine Anderson.)

This is the graduation photograph of Lt. James Hammond (standing, fifth from the right), who led his ROTC group at Hampton Institute and was instrumental in attaining civil rights for African Americans in Tampa in the 1960s. (Courtesy of James Hammond.)

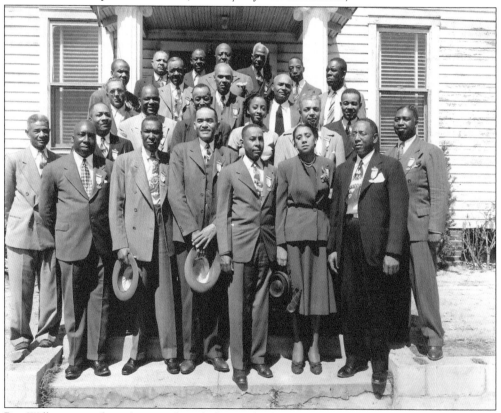

Roy Wilkins poses for a photograph with the Brotherhood of Sleeping Car Porters. He is standing in the center of the second row from the top. Robert Saunders left his post in the NAACP in 1966 to work with Wilkins in New York. (HCPL.)

Four

BUSINESSES

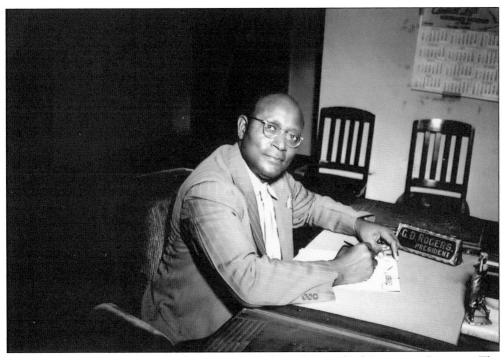

Garfield DeVoe Rogers Sr. was the founder and president of Central Life Insurance Company. The golfer penholder on his desk is a symbolic predictor of his life and his future philanthropic gift. He donated the money for the land that is now Rogers Park Golf Course. Rogers is shown here in his office on July 7, 1936. His grandson James Ransom shared that Rogers walked to Tampa from Georgia and was a mortician. Rogers was also a strong supporter of Bethune-Cookman College and an investor in Bethune Beach in Daytona. (HCPL.)

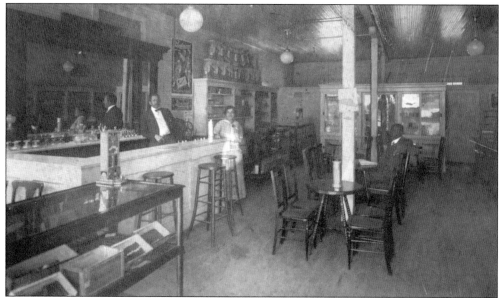

Walter Armwood is standing behind the counter of the drugstore he co-owned with his father, Levin Armwood. His wife, Hattie, is standing near him. Walter was an architect, a professor at Bethune Cookman College, a principal of Brewer Normal in South Carolina, and a Florida state supervisor for the US Bureau of Negro Economics. (USF.)

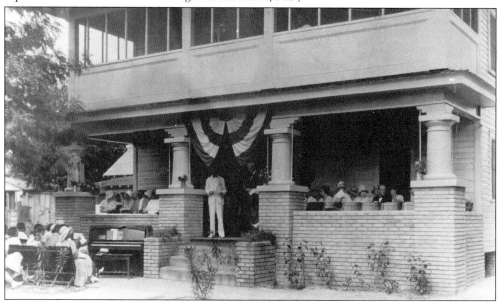

Seen here is the 1930 dedication of the Tampa Negro Hospital at 1615 LeMar Avenue. Officials and guests are seated on the decorated porch, and the audience is on the lawn along with a piano. Clara C. Frye opened a hospital for black patients in her home in 1908. Her dining room table was the operating table. The building shown was secured in 1923 and purchased by the City of Tampa in 1928. The Tampa Municipal Hospital, now Tampa General Hospital, did not admit African American patients until the 1950s. In 1938, the structure, in Roberts City on the west bank of the Hillsborough River, was dedicated as the Clara Frye Memorial Hospital. Howard W. Blake School was later built on the site. (HCPL.)

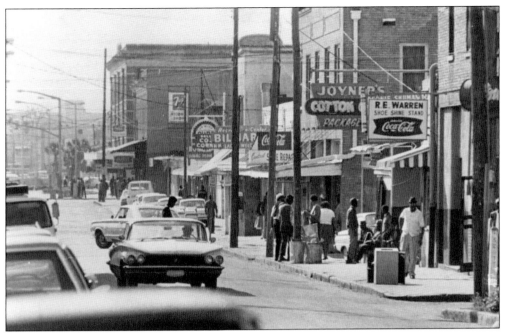

This is a view of Central Avenue, sometimes known as the "Harlem of the South." Joyner's Cotton Club was owned by Florida state senator Arthenia Joyner's parents. Central Avenue was the central area for African American business and social life. Ray Charles and countless other national performers entertained on Central Avenue. Eminent domain claimed it during the construction of Interstate 4. (USF.)

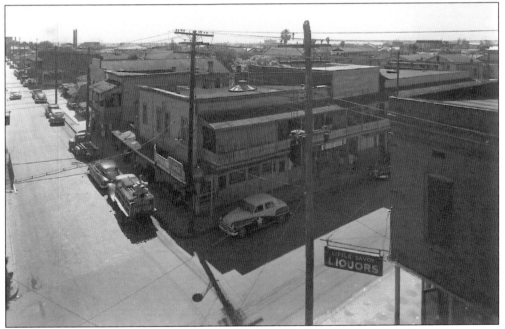

Across the street from Little Savoy Liquors was Kid Mason's, whose sign read, "Kid Mason is My Name and Pleasure is My Game." Central Quick Lunch was on the corner and was a popular sandwich shop. (USF.)

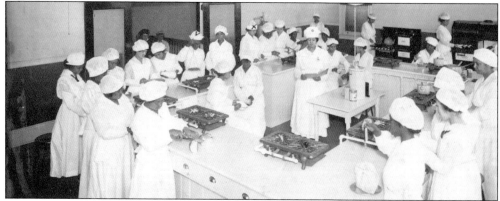

Blanche Armwood returned to Tampa in 1914 to work with the Tampa Gas Company, the Hillsborough County Board of Education, and the Colored Ministers Alliance to organize a domestic-science industrial school. Armwood started the Tampa School of Household Arts to teach African American women and girls how to use modern appliances in preparation for domestic servant work. Armwood repeated this model in Virginia, South Carolina, Georgia, and Louisiana. While in New Orleans from 1917 to 1920, she published a wartime cookbook, *Food Conservation in the Home.* (USF.)

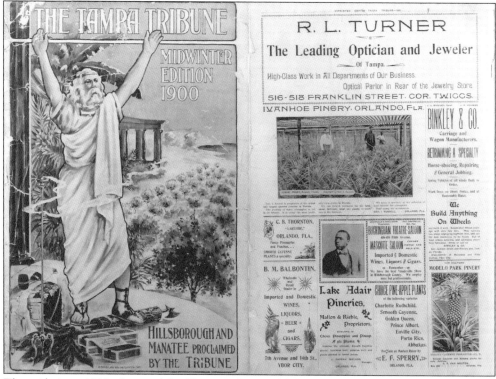

The midwinter 1900 edition of the *Tampa Tribune* published an advertisement for Chappelle & Donaldson, proprietors. Pat Chappelle was the business manager of the Buckingham Theatre-Saloon, at 416–418 Fifth Avenue, and the Mascotte Saloon, on the corner of Pierce and Polk Streets. They offered imported and domestic wines, liquors, and cigars. The advertisement states, "Remember—We have the best Vaudeville Show in Hillsborough County. We employ none but professionals." (HCPL.)

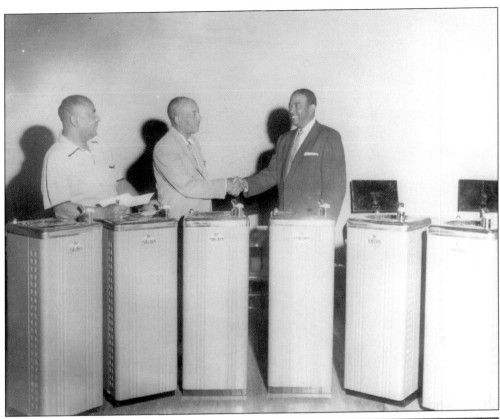

Leon Claxton and Ray Williams present water coolers donated by the Dads Club to Blake High School principal U.R. Thomas. Other members of the club included Rudolph Scrouz, Jim Williams, coach Charles Perry, and a Franklin Funeral Home owner. Claxton owned the hugely successful Harlem in Havana Revue and later the Harlem Revue, which traveled with the state fair. (Courtesy of George Robinson.)

Pattie B. Sherman Miller co-owned Roberts City Hotel with her daughter Eloise Jones. The hotel was located on Short Main Street in West Tampa. Miller is Clemmie James's aunt and Doris Ross Reddick's great-aunt. (Courtesy of Doris Ross Reddick.)

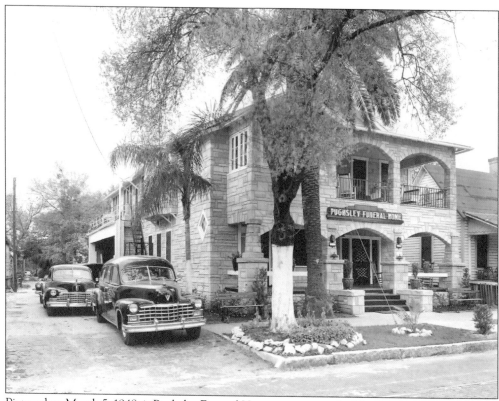

Pictured on March 5, 1948, is Pughsley Funeral Home, a two-story building with a masonry facade, at 1510 Jefferson Street. A longtime Tampa resident recalled hearses such as these being used to carry people to hospitals because there were no ambulances. According to procedure, the hearses parked at football games in case of injury. (Both HCPL.)

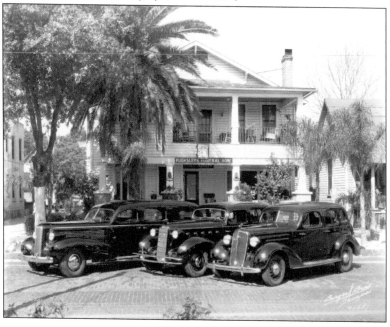

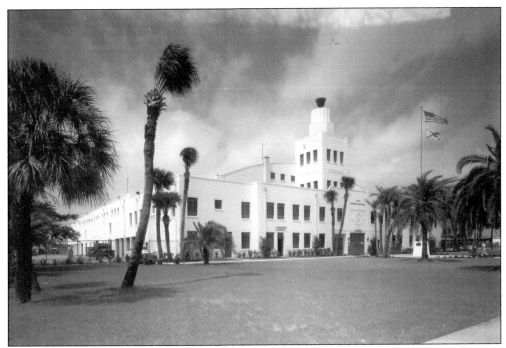

Fort Hesterly Armory is shown against the Florida sky. It was the site of both social and political activities. It was the place of choice to present and perform for both President Kennedy and Millie Jackson. (HCPL.)

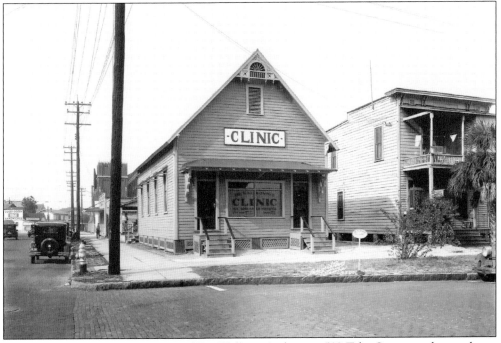

This is a December 12, 1931, view of Dr. Walkonig's clinic at 502 Tyler Street on the northeast corner of Marion Street. The window advertisement promotes that all diseases were treated there. Goody Goody Restaurant is visible on the far left of the photograph. (HCPL.)

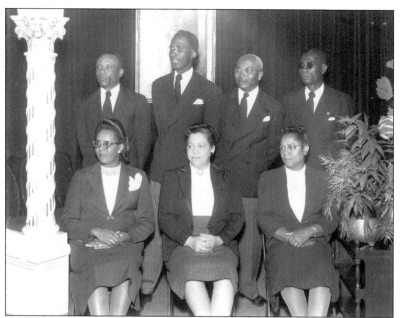

Preston Pughsley of Pughsley Funeral Homes, seated in the middle, is shown with her staff in a portrait taken on March 5, 1948. (HCPL.)

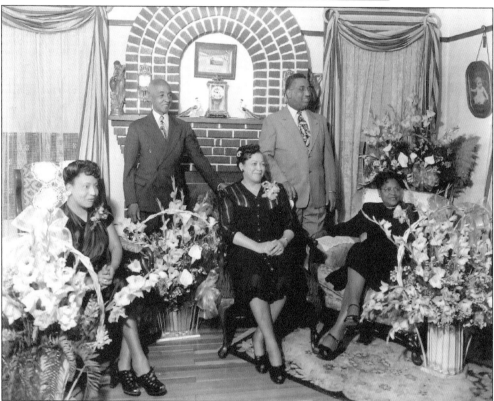

The owners and staff of Pughsley Funeral Home are shown here, with Preston Pughsley seated in the center. The company existed from at least 1937 to 1948. Standing on the left is Chappelle Williams Sr., who was the brother of Dr. Reche Williams and was also associated with Ray Williams's funeral home. (HCPL.)

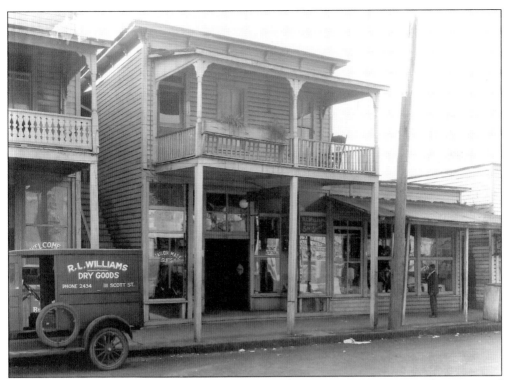

R.L. Williams Dry Goods Store was located at 1111 East Scott Street in Tampa. This was one of the businesses in the renowned Central Avenue business district. (HCPL.)

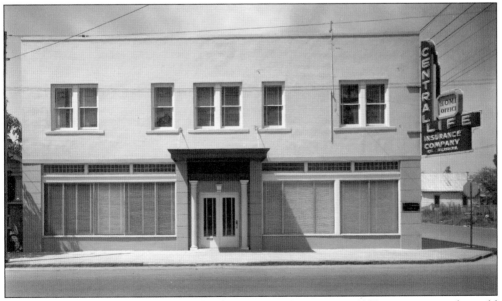

G.D. Rogers helped create the Central Life Insurance Company in 1922 as an agency that sold policies to black people. Mary McLeod Bethune and *Florida Sentinel Bulletin* founder C. Blythe Andrews were also a part of this venture. Central Life opened its first office on Harrison Street with six employees. This building, located at 1416 North Boulevard, is seen here on March 3, 1954. The upstairs window on the far right was Dr. Al Lewis's medical office. (HCPL.)

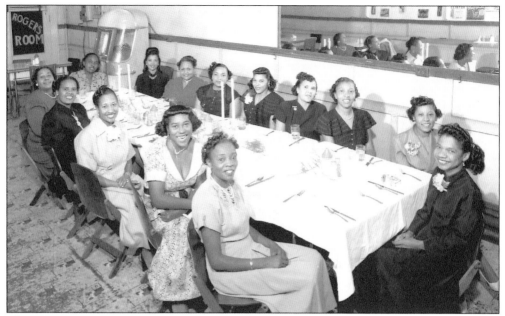

The Rogers Dining Room was located at 1030 Central Avenue and operated by Ozepher Harris and her sister Ally. It was a part of the Pyramid Hotel. Sitting among the women in the back row at this 1951 meal are Vina Sysdell, Ozie Due, and Mrs. McFarland Lester. Sitting in the front row, from front to back starting with the woman in the lighter dress, are an unidentified person, Marsha McFarland Reedy, Hilda Smith, and Mrs. Gooden. (HCPL.)

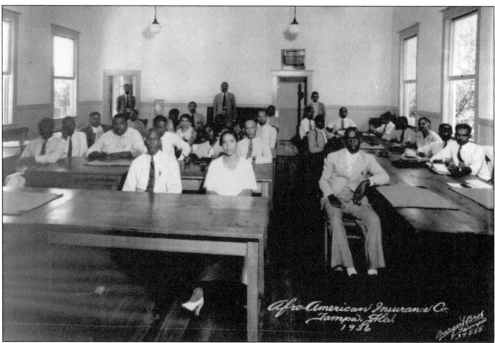

Afro-American Insurance Company was an Atlanta-based insurance company with a Tampa office on Central Avenue. It was one of at least two African American companies serving the community. This photograph was taken on August 3, 1936. (USF.)

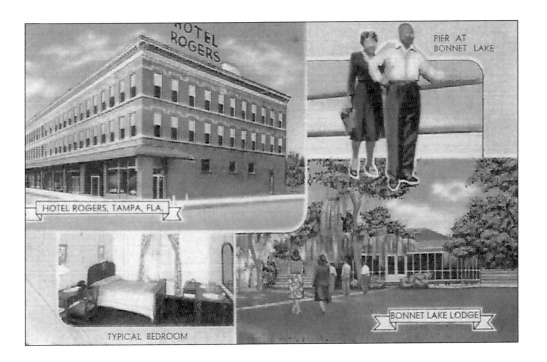

The Rogers Hotel was owned by G.D. Rogers and was managed by William Hammond. The restaurant on the ground flood was managed by Ozepher Harris, who continues to be remembered for the formal and respectful way she served patrons. The hotel was later name the Pyramid Hotel. The postcard is a rare glimpse into a grand African American hotel. Shown below are William and Lucille Hammond, James Hammond's parents. (Both courtesy of James A. Hammond.)

Attorney Harold Jackson Sr. (right), along with Forham and Francisco Rodriguez, owned an African American law firm operating on Central Avenue. Jackson was the first African American attorney since 1898 to practice in Tampa. He also had an office in St. Petersburg. Jackson is Harold Jr. and Myron Jackson's father. (Courtesy of Myron Jackson.)

Attorneys Francisco Rodriguez (left) and Harold Jackson were law partners with an office on Central Avenue. Rodriguez's twin brother, known as "Proff," was a band director at Middleton High School. (Courtesy of Myron Jackson.)

C. Blythe Andrews was secretary and treasurer of Central Life Insurance when he posed for this photograph on July 7, 1936. He went on to found the *Florida Sentinel News*, which still serves as the primary source of African American–related news in the Tampa Bay area. (HCPL.)

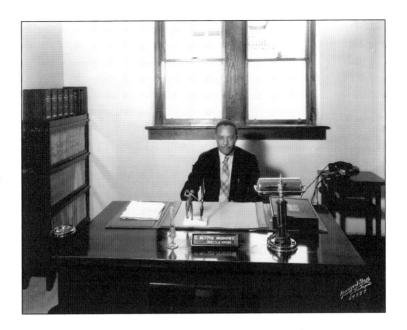

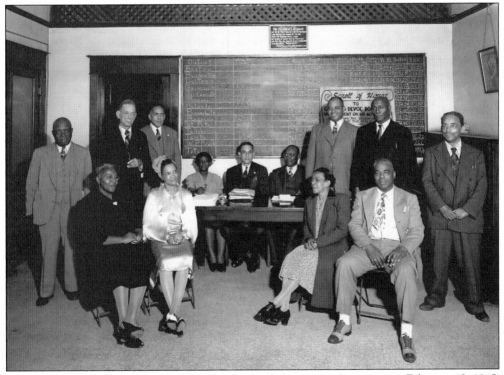

Pictured here are the board members of Central Life Insurance Company on February 13, 1945. G.D. Rogers Sr. is seated at the table on the right, looking in the direction of his wife, Minnie Rogers, who is seated in front with a dark suit on. Standing second from the left is Stubbs Pughsley, followed by Lee Davis. The progress board reveals that in 1945 the company served Bartow, Bradenton, Daytona, Gainesville, Jacksonville, Orlando, Panama City, Pensacola, St. Petersburg, Tallahassee, Tampa, and West Palm Beach. (HCPL.)

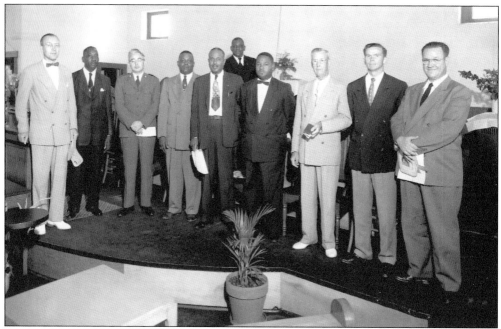

Reverend Newsome, a Methodist minister (fourth from the right), was also a photographer for the *Florida Sentinel News* in the 1950s. He was assigned to photograph President Kennedy when he came to Tampa in 1963. He also mentored George Robinson's brother Walter Robinson. (HCPL.)

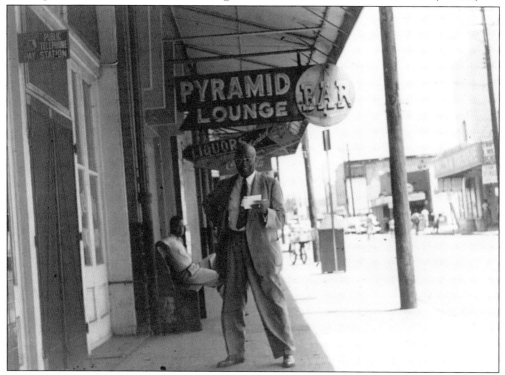

This is a photograph of Mr. Harris, known as the "Suit Man," standing in front of attorney Harold Jackson's office on Central Avenue in 1960. (Courtesy of Myron Jackson.)

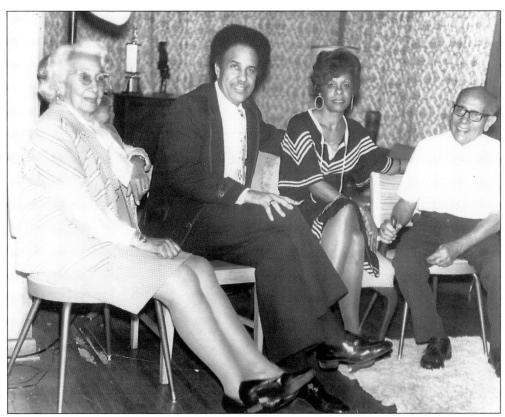

Shown above are Lucille, James, and Evelyn Hammond and Dr. Ervin. James, a 1946 Middleton graduate, was the first African American licensed as an electrical contractor in Hillsborough County. He also founded Tampa Hillsborough Action Plan (THAP). Hammond established the "White Hats," which curtailed a major race riot in 1967 following the death of Martin Chambers. He helped organize desegregation sit-ins in Tampa. He retired from the Army in 1979 as a lieutenant colonel. He was the founder of COPE (Compensatory Pre Primary Education), later operated as Head Start. Pictured below riding in a truck are Hammond's sons Kevin and Gary. (Both courtesy of James Hammond.)

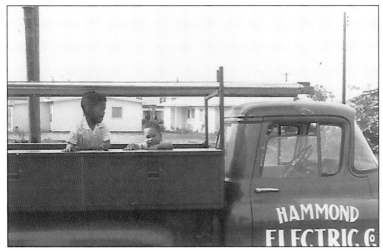

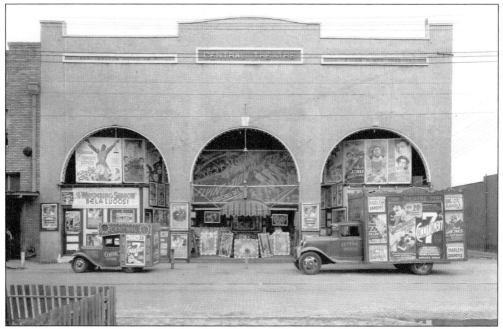

Shown with every advertising space covered with movie posters is the Central Theater, located at 1201–1203 Central Avenue, in 1934. There is even an announcement about the showing of Paul Roberson's *Emperor Jones*. Movie posters also covered advertisement trucks. (HCPL.)

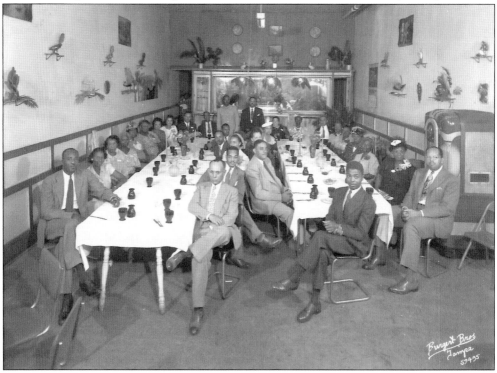

The Tampa Urban League held its banquet in Tampa on June 11, 1946, in the Rogers Dining Room in Hotel Rogers on Central Avenue. (HCPL.)

Carrie Hills Graham, Richedean Hills-Ackbar's grandmother, would get a carload of gladiolas from a processing facility such as the one seen here and sell them in the community. She also sold periodicals such as *Jet* magazine, the *Pittsburgh Courier*, and the *Amsterdam News*. (Right, courtesy of Richedean Hills-Ackbar; below, HCPL.)

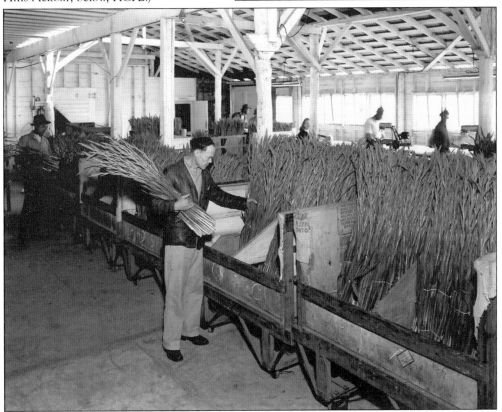

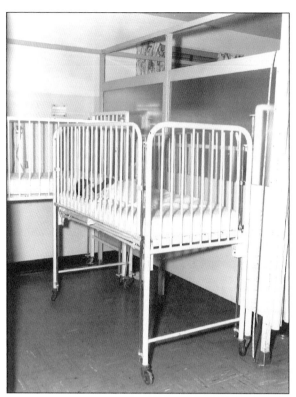

The baby lying in the child's crib shown here is being cared for on the children's ward at Clara Frye Memorial Hospital on January 4, 1960. (HCPL.)

The Palace Drug Store was located on the northeast corner of Scott Street and Central Avenue. It is seen here on September 2, 1949. (HCPL.)

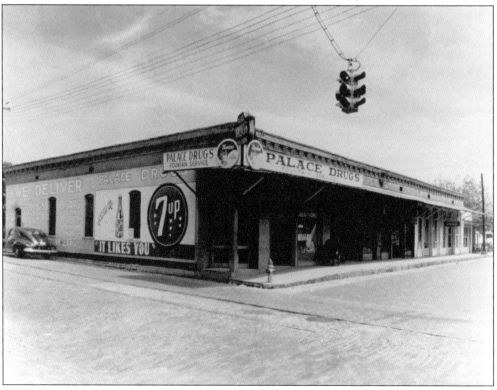

Five

INDIVIDUALS

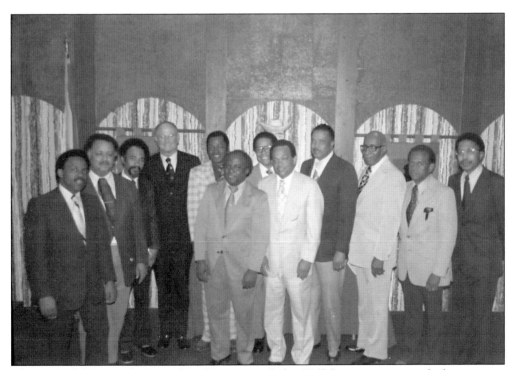

This powerful group of 12 men from Tampa traveled to Tallahassee to meet with the governor at his request. From left to right are Judge George Edgecomb, Moses White, Charles "Goosby" Jones, Malcolm Beard, Bob Gilder, Rubin Padgett (behind Gilder), Perry Harvey Jr., C. Blythe Andrews Jr. (behind Harvey), Clarence Wilson, Rev. Leon Lowery, Harold Clark, and James Hargrett. (Courtesy of Harold Clark.)

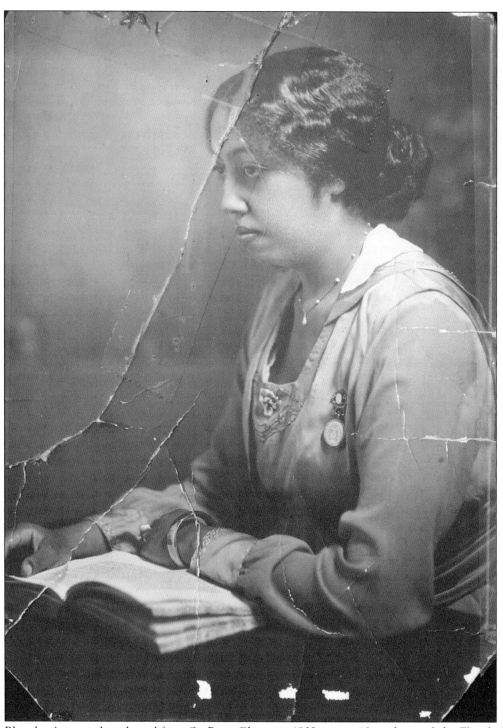

Blanche Armwood graduated from St. Peter Claver in 1902, at age 12, and passed the Florida State Uniform Teachers Examination that same year. She graduated summa cum laude in 1906 from Spelman Seminary (later Spelman College) and earned a teaching certificate. At age 16, Armwood started teaching in Tampa's black public school system. (USF.)

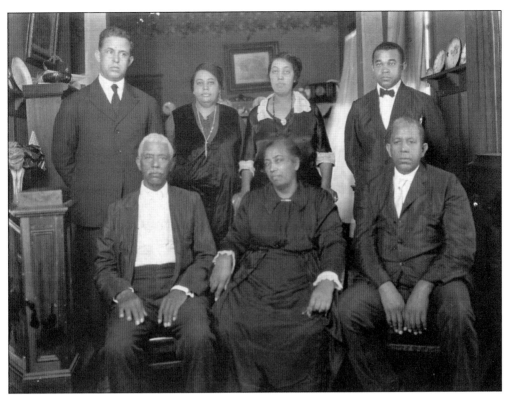

Seated in front in this Armwood family photograph are Blanche Armwood's parents, Levin Armwood Jr. and Margaret "Maggie" Armwood, and her brother Walter Adam Armwood. Standing on the left are her brother-in-law and sister, James Street and Idella Armwood Street, followed by Blanche Armwood Beaty and her husband, Dr. John Beaty. (USF.)

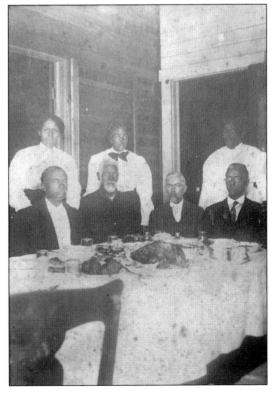

Seated from left to right are Levin Armwood Jr., with his wife, Maggie, behind him; Louis Armwood and his wife, Ida; Levin Armwood Sr.; and Owen and Sallie Armwood. Levin Sr. was the pastor of his church and the first African American police officer, serving as deputy sheriff and supervisor of county road construction by prisoners. He also co-owned a drugstore, The Gem, which was Tampa's only African American–owned drugstore for many years. (USF.)

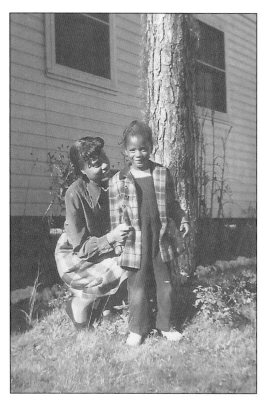

This young lady, Martha H. Kennedy, was a science teacher at Booker T. Washington Junior High School. She served as an educator for 37 years. She is shown here with her daughter Sandra Kate Williams. Martha is also attorney Hewitt Smith's mother. (Courtesy of Hewitt Smith.)

Fredonia Hills worked at the Florida Hotel in downtown Tampa and then went to night school at Middleton High School. She ran the family pawnshop, Hills Pawn Shop. She was also a hairdresser, a member of St. Luke AME Church, and an Eastern Star. Her daughter Richedean Hills-Ackbar has dedicated her life to serving the elderly. (Courtesy of Richedean Hills-Ackbar.)

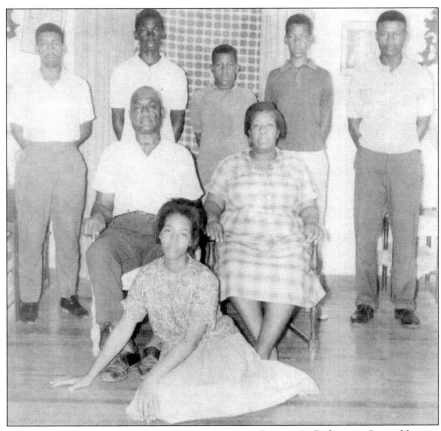

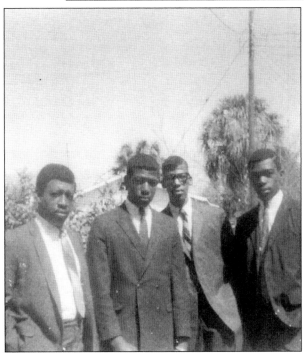

George A. Robinson Sr. and his wife, Jessie, successfully provided all six of their children with a college education. When George Jr. graduated, he handed his diploma to his mother, saying, "Here, this is for you." She said he was the oldest, and for her to have a chance with the others, she had to make sure he finished college. They all did and became extremely productive: George (First African American admissions officer for USF); Lorenzo (2014 Teacher of the Year); Richard (expressway and airport construction engineer who also invented a liquid tap); Lawrence (publisher and inventor of water regulation of a hydrologic sprinkler system); Walter (invented the water shoe); and Gloria (founded a music school that is 40 years old and going strong). (Both, courtesy of George Robinson Jr.)

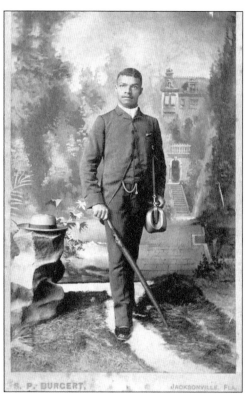

Shown is a very stately gentleman from the Armwood family collection. The family was considered affluent, and his attire supports this assumption. (USF.)

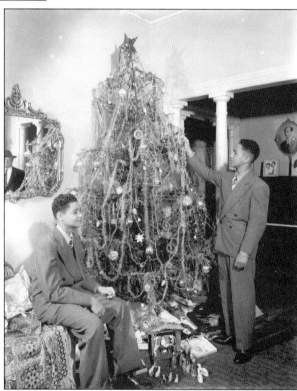

This photograph shows a Christmas celebration at the home of Dr. A. Howell in December 1947. (HCPL.)

Inez Austin Boyer was the first president of the Tampa Metropolitan Section of the National Council of Negro Women, Inc., when it was organized in 1947. She is seated here with her daughter and son-in-law standing behind her. (HCPL.)

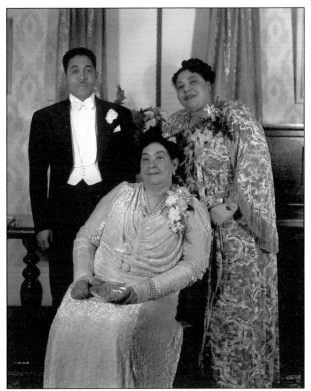

"Big Jim" Williams was a star football and basketball player at Middleton High School, a World War II veteran, and an All-American quarterback for Florida A&M in 1948. In 1949, Williams coached at Don Thompson Vocational High, which later became Blake High School. He led these schools to impressive winning streaks, including two state championships and two unbeaten seasons. Blake High School's stadium is named in his honor. (HCPL.)

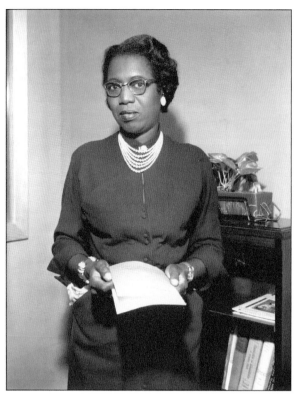

Margaret Blake cofounded the Alpha Pi chapter of the Alpha Kappa Alpha (AKA) sorority. In 1931, she taught music and English at Booker T. Washington High School, and her husband, Howard W. Blake, was principal. Together, they owned what was known as the "Black Service Station." Margaret created a community health program that gained national recognition and was also a counselor at Gibbs Junior College in St. Petersburg. (HCPL.)

Pictured here is Blake High School counselor Ethel Jones. (HCPL.)

A very popular Tampa couple, coach Billy Reed and his wife, Dorothye, are shown here on their wedding day with guests (from left to right) unidentified, Mrs. Artest, Doris Perry, Rowena Brady, Ursel Williams, Thelma Kent, unidentified, Katherine Thornton, and Timothy Thornton, followed by the bride and groom. (Courtesy of Billy and Dorothye Reed.)

The dedication to education of Doris Ross (Perry) Reddick and her mother, Clemmie Ross James, have been memorialized in the forms of Doris Ross Reddick Elementary School and Clemmie James Elementary School. Clemmie (right) was a teacher and was active in the struggle for equal pay for African American teachers. Doris was the first African American woman elected to the Hillsborough County School Board and also served as its chairperson. (Courtesy of Doris Ross Reddick.)

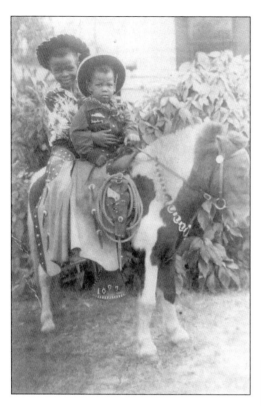

From left to right, Walter and Lawrence Robinson enjoy a pony ride in the safety of their own yard. The pony owner traveled to the neighborhood offering rides to children and then captured the moment with his camera. (Courtesy of George Robinson.)

Harold Clark is a former Blake High School principal who initially served 28 years in the school system. During his tenure with the Hillsborough County school system, Clark served on numerous boards, including the Tampa Urban League, the YMCA, as chairperson of the Hillsborough Community College Board of Trustees, the Equity Committee and the Minority Development Committee for the University of South Florida, the Redland Migrant Christian Association, the Hillsborough Educational Partnership Foundation, and the Hillsborough County Grievance Association. Clark returned to the system for an additional 20 years at the request of school board chairperson Doris Ross Reddick in order to provide an ethnic and ethical balance in the school discipline review process. An elementary school in West Meadows, in New Tampa, is named for him and his 48 years of service. (Courtesy of Harold Clark.)

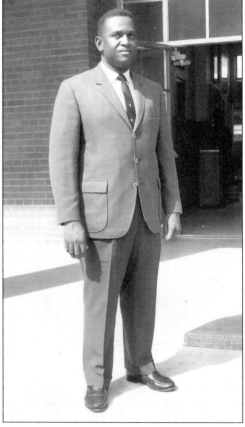

This gracious young lady, Olivia Fatherly, became a powerful speaker and vocalist. She is also Delatorro and Michael McNeal's mother. She was a member of the Ball family and extremely active in St. John Progressive Missionary Church, serving church families from the F.G. Hilton family to the Bartholomew Banks family. (Courtesy of Michael McNeal.)

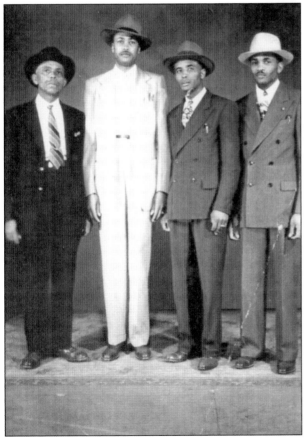

Shown here from left to right are Byrd Reynolds and his sons Leroy, Rubin, and Gardner "Doll." Leroy was a lifelong barber in Tampa. Walter L. Smith, the son of Rubin and his wife, Eva, became the seventh president of Florida A&M University. Rubin and Eva are also the uncle and aunt to television personality Judge Greg Mathis. Byrd Reynolds's great-granddaughter, Sasheer Zamata, became the first African American female regular on *Saturday Night Live*. (Courtesy of Osborne Odom.)

This photograph of an unidentified member of the Hills family is a reminder of the role hats played as a cultural norm in the African American society. (Courtesy of Richedean Hills-Ackbar.)

Richard Hills was one of the building contractors who helped develop Tampa. Some buildings he constructed are still standing, including Brookin's Point, on Twenty-ninth Street, where Dr. Brookin's office was located. Hills was the uncle of attorneys Delano and Frank Stewart and the father of Richedean Hills-Ackbar. (Courtesy of Richedean Hills-Ackbar.)

Pictured are Edward Hill and his wife, Carrie Smart Hill, who were grandparents to attorneys Delano and Frank Stewart. Standing in front is Edward Jr. These Eddies are two of the seven Eddies in the family. (Courtesy of Richedean Hills-Akbar.)

Born Jimmie Jackson, this young man grew up to be Ali Akbar. Ali was a community organizer and the owner of 4 J's Metal Fabrication, Inc. His work can be seen in backyards and municipal buildings, including the City of Tampa Museum, the University of Central Florida, the new Blake High School, Nathan B. Young High School, and the MacDill Air Force Base Medical Building. (Courtesy of Tanya Jackson Akbar.)

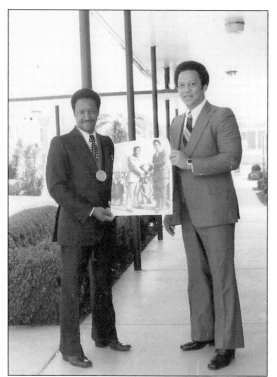

Dr. Walter L Smith Sr. (left) is receiving an award from Alton White for outstanding leadership in local, state, national, and international education. Dr. Smith developed a program to expand and enhance higher education in North, Central, and South Africa. White was the head of the City of Tampa's housing department and created a model home program that was adopted by Gov. Reuben Askew. White also served as vice mayor of Tampa during Dick Greco's administration. Dr. Smith was the seventh president of Florida A&M University. (Courtesy of Walter L. Smith Sr.)

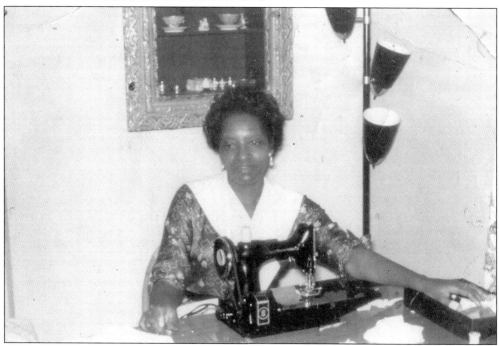

Eva Reynolds is shown at her sewing machine, which was her resource for clothing design and upholstery for more than 50 years. She also served as head alteration person in the Davis Island shop for *Vogue* magazine. She was married to Rubin Reynolds for 62 years and is Dr. Walter L. Smith's mother. (Courtesy of Walter L. Smith Sr.)

Six

ORGANIZATIONS

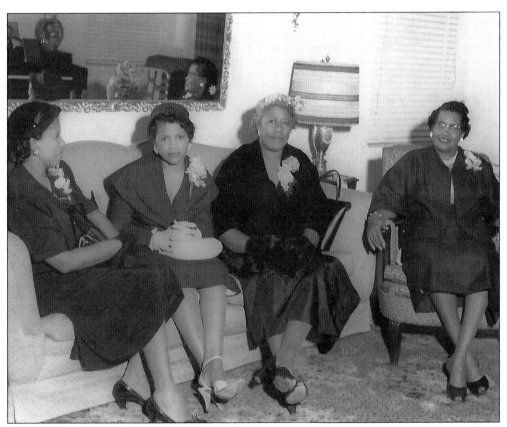

The well-dressed ladies in this 1955 photograph were members of both the African Methodist Episcopal Church and the National Council of Negro Women. Shown from left to right are Clemmie James, Mildred Douglas, Dr. Heath (the pastor's wife and "first lady" of Allen Temple), and Rachel James. (Courtesy of Doris Ross Reddick.)

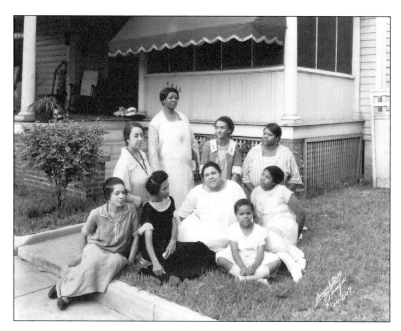

The woman seated in the center of this image, wearing a light dress, is believed to be Clara Alston. Blanche Armwood is on the left wearing a striped blouse. The photograph was taken at the Urban League on May 9, 1925. (HCPL.)

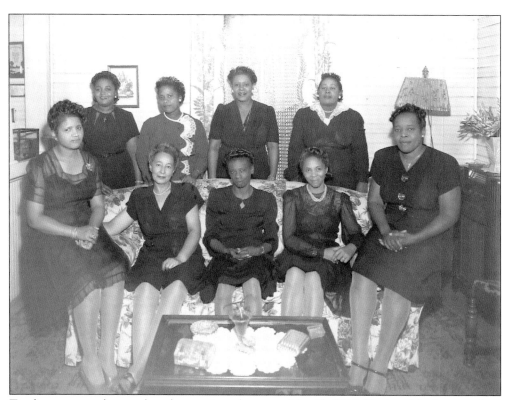

Teachers are seen here gathered at a private home on May 31, 1946. During this time, teachers were strategizing for equal, or at least better, pay and discussing teaching techniques. Sitting second from the left is Lillian Hammond. (HCPL.)

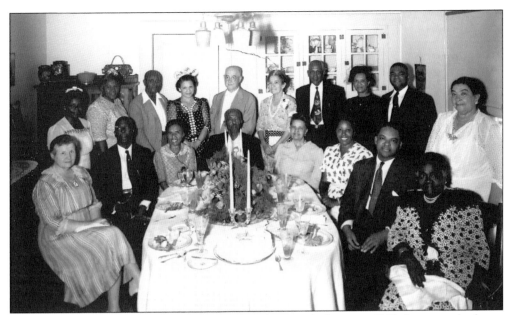

According to local historian Fred Hearns, this photograph depicts a 1948 dinner at the home of Rev. and Mrs. Marcellus D. Potter, seated second and third from the left, honoring Dr. Mary McLeod Bethune, who is seated on the far right. Inez Boyer is standing behind her in white. G.D. Rogers is standing third from the left. Dr. Bethune was the founder of Bethune-Cookman College and a cofounder, shareholder, and the only female president of Central Life Insurance Company. (HCPL.)

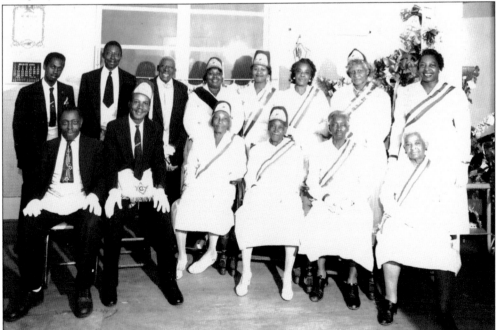

The two women seated in the middle are "Free and Accepted Mason and Eastern Stars" and are identifiable by their white shoes. The other women are Mason wives of Knights of Pythias. (HCPL.)

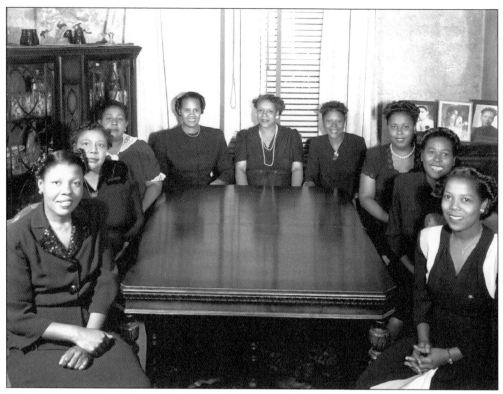

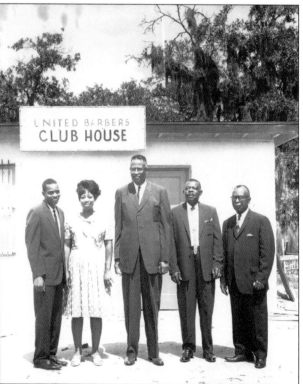

From left to right are two unidentified ladies, Inez Doby, Anita Gooden or Vyerl Davis's mother, unidentified, Eloise Bailey, unidentified, Marsha McFarland Reddy (Dr. Fredrick Reddy's mother), and Vender Rae McFarland Hewitt. All of the ladies identified were members of the Zeta Phi Beta Sorority. (HCPL.)

Standing from left to right are unidentified; Frankie Reynolds; her husband, barber Leroy Reynolds; John Houston, who had a barbershop in the longshoremen's building that turned 100 years old in 2014; and unidentified. They are standing in front of the United Barbers Club House. (Courtesy of Elaine Harris.)

Members of the Omega Psi Phi fraternity pose on October 4, 1946, the day they organized, with their fraternity seal. They are, from left to right, (first row) Garland V. Steward, J.T. Brooks, R. Reche Williams, and Grant B. Brinson; (second row) Wilson Lester, Hubert Dabney, John Henry Evans, Council Dixon, James Hargrett Sr., and Perman Williams. (HCPL.)

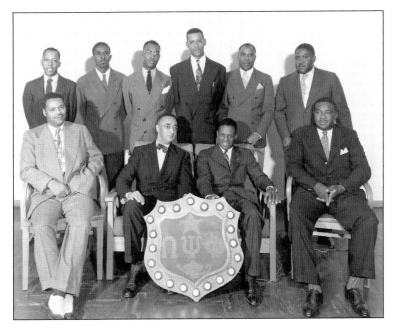

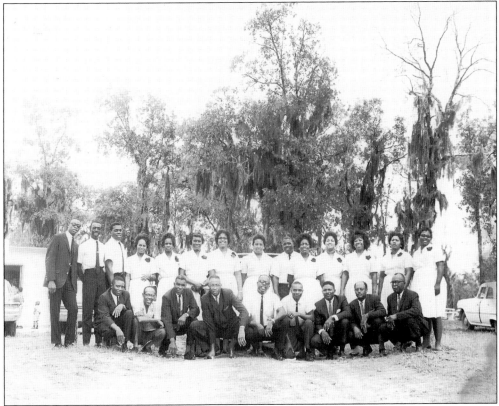

Kneeling third from the left is Robert Saunders, with Leroy Reynolds to the right of him; second from the right is Charlie Maddox, the husband of Susie Maddox and the godfather of Clemmie Perry. (Courtesy of Elaine Harris.)

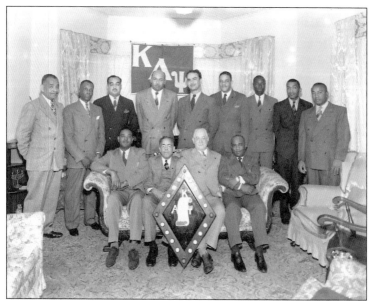

The Kappa Alpha Psi fraternity members shown here are, from left to right, (seated) W.R. Thomas, E.E. Broughton, Dr. Leroy Howell, and J.W. Lockhart; (standing) Marcellus Henderson, Dr. E.O. Archie, Johnnie Clark, unidentified, Matthew Estares, A.J. Farrell, unidentified, Edward Davis, and Thomas Riser. They posed for this image on March 12, 1947. (HCPL.)

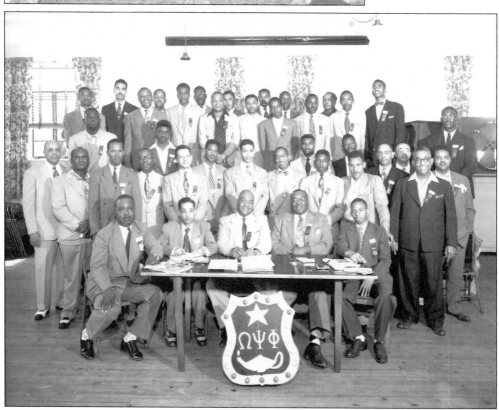

The Tampa Omega Psi Phi was formed in 1946 with approximately 10 founding members. By 1952, the fraternity had grown into a formidable organization. Three of the founding members are identified in the photograph as G.D. Stewart, John Henry Evans, and Grant Brinson. In addition, the third person from the right in the top row is a Mr. Webb from Lakeland. Edwin Artest is the second person from the left in the second row. (HCPL.)

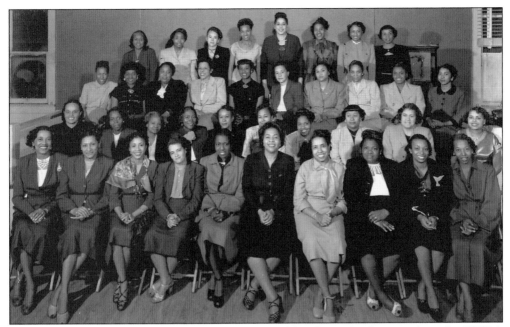

Alpha Kappa Alpha (AKA) sorority members posed for this 1951 photograph at the YWCA building at 1008 East Kay Street. The renowned Margaret Blake is third from the left in the first row. Eloise Baily is fourth from the left in the second row, and Jessie M. Artest is third from the right. Effa Ruffin, who was an 11th-grade English teacher, is third from the left in the third row. Grace Bowden is fourth from the left in the back row. (HCPL.)

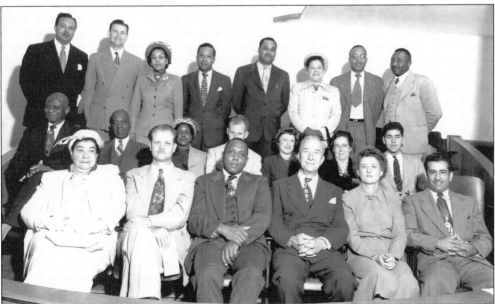

Shown are the members of the 1951 board of directors of the Tampa Urban League. Seated in the first row on the far left is Inez Boyer, and third from the left is Mathew Gregory, who is remembered as a onetime vice president of the NAACP. On the far left in the second row is Dr. Reche Williams Sr. Standing in the back row, third from the left, is Dora Reeder, a high school principal. Standing third and second from the right are Preston Pusley and Ben D. Griffin. (HCPL.)

This photograph shows the Democratic Voters League at Rogers Hotel in 1948. Lee Davis and Robert Saunders are seated second and third from the left, Mr. Brody is standing second from the left, and Perry Harvey is standing second from the right. (HCPL.)

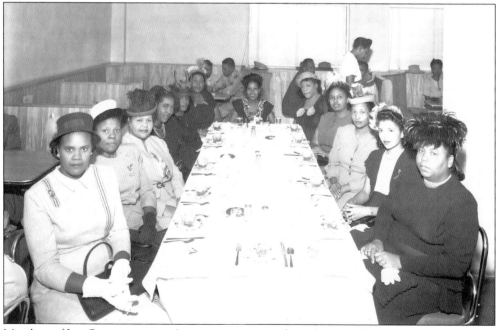

Members of Les Quinze, a women's organization, pose for a photograph at a special lunch at the Cotton Club in 1947. Anita Gooden is seated on the far left in the foreground. The Cotton Club was owned by Henry Joyner and located at 1202 Central Avenue. Joyner's daughter Arthenia Joyner became a Florida state senator. (HCPL.)

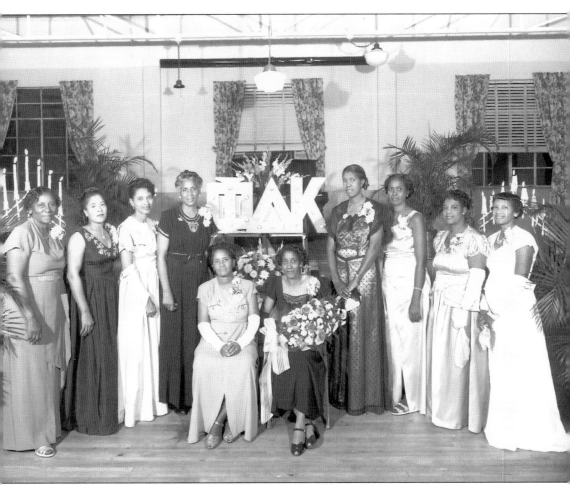

This 1948 formal event of the Phi Delta Kappa sorority includes Hilda Turner (fourth from the right), who was the plaintiff in the 1943 NAACP case Turner v. Keefe that successfully led to equal pay for African American teachers in Hillsborough County. Third from the left is Elise Blanks, who attorney Delano S. Stewart credits as being one of his more inspirational teachers. The woman seated on the left is identified as Molly Boone. (HCPL.)

Standing in the back row are fifth-grade Lomax teacher Charlotte Lewis, Mrs. Henry Peoples, and Mrs. Clemmons. The lady seated in the center on the sofa has been identified as the secretary at Middleton High School. Seated on the far right is Eddie Williams. They are meeting at Annie G. Foster's home at 1613 Governor Street. (HCPL.)

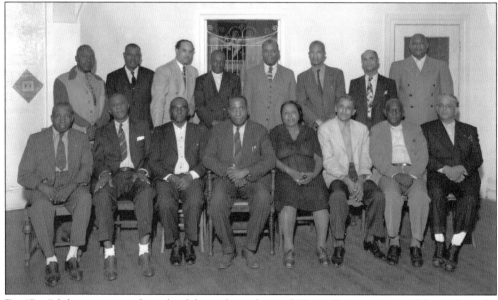

Dr. "Pap" Johnson is standing third from the right, and Henry Joyner is second from the right in this November 12, 1947, photograph of the members of the Tampa Progressive Voters League during a meeting at the Rodgers Hotel at 1028 Central Avenue. Lee Davis is seated on the far right. It was said that Dr. Johnson would drive through segregated Georgia in a suit and top hat. When he was stopped, he would pull out his card with "Dr." on it and show it as if he was a chauffeur, and they would let him proceed. (HCPL.)

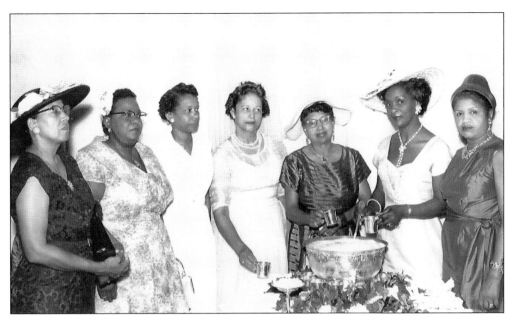

Listed from left to right are Clemmie James, Litha Davis, Mary ? , Viola Pope, Fannie Ayers Ponder, Ozepher Harris, and Mildred Douglas. They are attending a National Council of Negro Women's meeting at Pope's home. Ponder, of the St. Petersburg section, served as organizing consultant of the Tampa Metropolitan Section in 1947. Ponder also had national responsibilities and was a great friend of national founder Mary McLeod Bethune. (Courtesy of Doris Ross Reddick.)

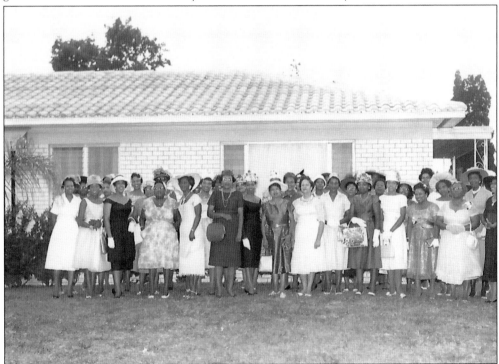

Also known to be in attendance were Edith Meteye, Eloise Davis, Doris Reddick, Cancerina Martin, Mamie Shields, Henri Phillips, and her son Ricky Phillips. (Courtesy of Doris Ross Reddick.)

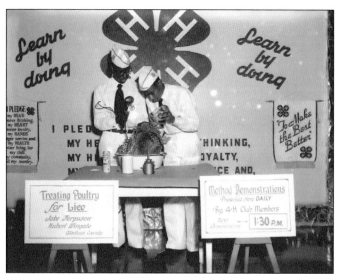

African American 4-H members perform a poultry care demonstration at the Florida State Fair in February 1953. (HCPL.)

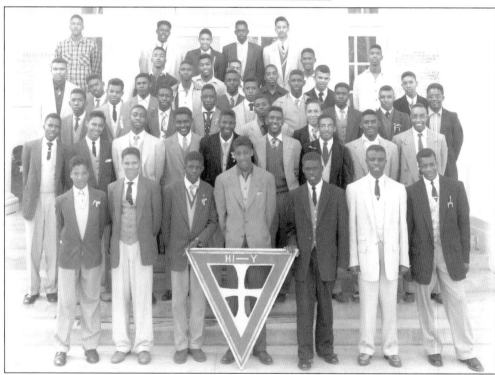

This entry is dedicated to attorney Frank Stewart, who gave life to the names listed here; he died a few days later. These members of the HI-Y Club are, from left to right, (first row) Jorge Arenas, Frank S. Stewart, Al Louis, Rudolph Arnao, two unidentified, and James "the Angel" Murray; (second row) Theodore Myles, Marion Reeves, unidentified, John Thornton, two unidentified, Curtis Young, Larry Houston, and Herbert Montana; (third row) two unidentified, Marion Bright, two unidentified, E.J. Huges, Leonard Harris, unidentified, and advisor James Lovett; (fourth row) Ed Jennings, Rudolph Riley, four unidentified, Lawrence Anderson, Coleman Beamon, and (far right) Pinder Morrison; (fifth row) four unidentified, Clarence Seniors, Clarence Frazier, and Benny Sheehy; (sixth row) Palmer Wynn, unidentified, Robert Right, unidentified, and Robert Nelson. (HCPL-BB.)

Seven

CHURCHES

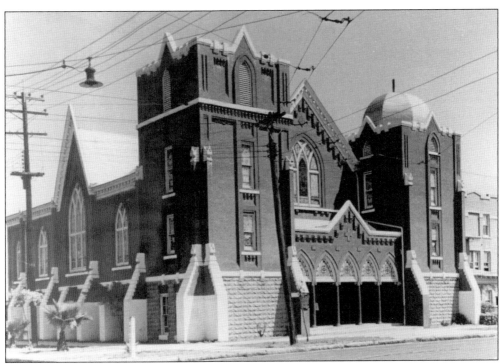

St. Paul AME Church, at 506 East Harrison Street, was founded around 1870 and was host to many celebrities through the years, including Pres. Bill Clinton, Supreme Court justice Thurgood Marshall, singer Ray Charles, activist Jesse Jackson, and NAACP president Benjamin Hooks. The three-story structure to the far right is Harlem Academy Elementary School on Morgan and Harrison Streets. (HCPL.)

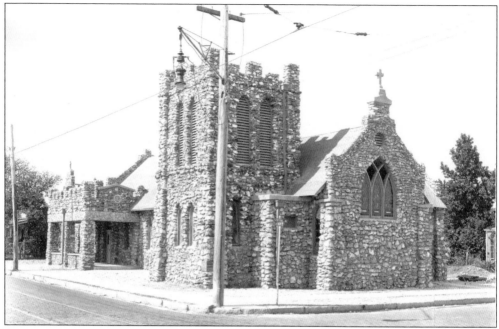

St. James Episcopal Church (now St. James House of Prayer) was organized in 1895 as an Anglican Episcopal church to serve an expanding black Bahamian and Cuban immigrant population brought to the area by the cigar industry. The "rock church" was erected in 1922 and dedicated in 1923. The Reverend William C. Richardson, MD, purchased and donated the land and personally spearheaded the construction of the church. Architect Louis A. Fort's design included a tower, battlements, stained-glass windows, 16-inch-thick concrete walls on the interior, and exterior walls composed entirely of flint rock stacked with mortar. The rocks were collected from the bottom of the Hillsborough River where it empties into the bay. The rocks did not occur there naturally; they came from all around the world aboard the sailing ships of centuries past. (HCPL.)

Pictured at his desk is moving contractor John Bates Henry, who began with a team of mules and a wagon and later operated with a truck. He helped relocate Pleasant Chapel AME Church from the Garrison to East Tampa, and in 1922 he transported the decorative stones from the Hillsborough River to form the facade of the St. James Episcopal House of Prayer Church at Michigan Avenue (now Columbus Drive) and Central Avenue. (Courtesy of Fred Hearns.)

The young man seated at the piano on the left is identified as Mr. Brody, the brother of Altamese Brody. The young lady is Isabell Myrick. They are posing for the camera in the Art Fellows Hall. (HCPL.)

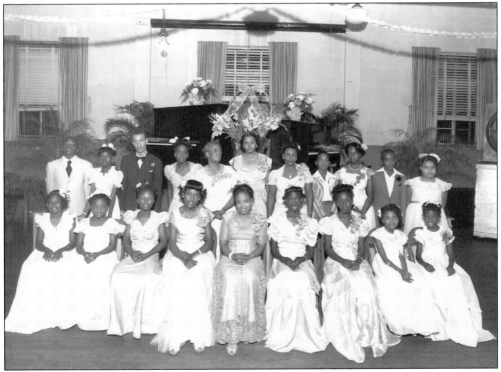

This formal affair took place upstairs in the Art Fellows Hall on the corner of Scott Street and Central Avenue. Pictured in the center of the front row is Isabell Myrick, and Josephine Brody is standing on the far right in the second row. (HCPL.)

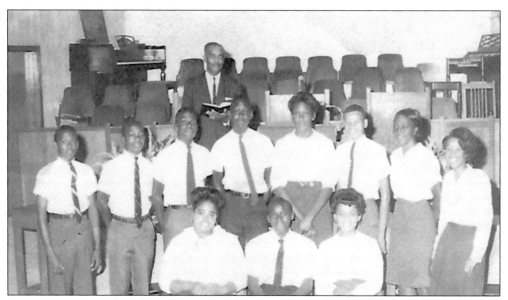

Pastor F.G. Hilton of St. John Progressive Baptist is shown here with the youth choir. Pastor Hilton is credited with being a master mentor and producer of pastors. To his credit are three well-known pastors: Arthur Jones, Earl Mason, and Bartholomew Banks. Hilton was president of the Progressive Mission and Education Convention at the time of this photograph, and Reverend Banks is president today. (Courtesy of Michael McNeal.)

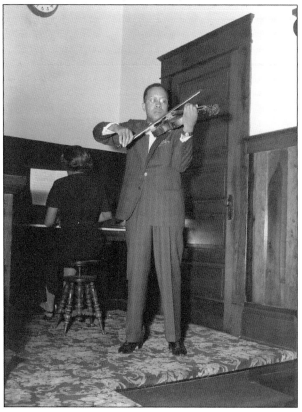

This gentleman is playing a violin at St. Paul AME Church, an example of the diverse musical talents that existed and were appreciated in Tampa. This photograph was taken on February 12, 1948. (HCPL.)

Eight

SCHOOLS

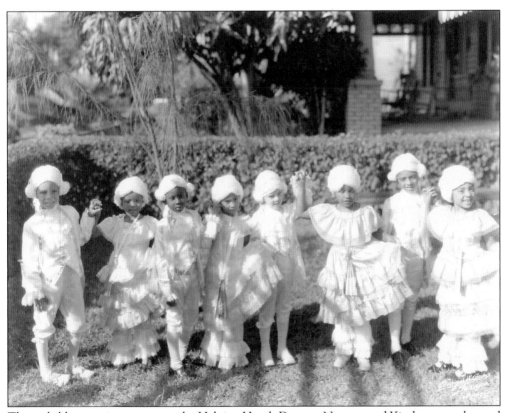

These children are in costume at the Helping Hands Daycare Nursery and Kindergarten, located at 1609 Central Avenue. Included in this photograph, taken on November 3, 1936, are C. Blythe Andrews Jr., Barbara Knuckles, Stubb C. Pughsley, Peggie Archie, Kennedy Munford, and Andrew Foster. Coach Billy Reed identified these children as his former classmates. (HCPL.)

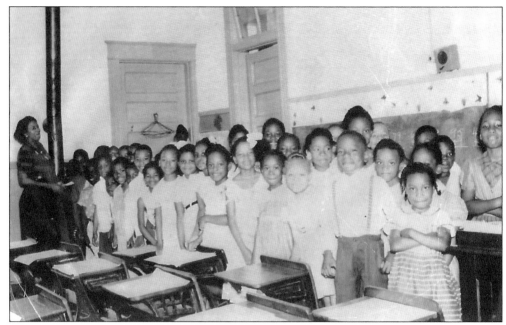

Clemmie James is shown here with her elementary students at Lomax Elementary during the 1933 or 1934 school year. Above the students is an intercom, which was a part of the first system to be installed in an African American school in Tampa. (Courtesy of Doris Ross Reddick.)

George S. Middleton High School was the first high school for African Americans in Hillsborough County when it opened in 1934 on Twenty-fourth and Chelsea Streets in East Tampa. A 1940 fire destroyed the school, but it was rebuilt. It was rebuilt after a second fire in 1968 and then became Middleton Junior High School in 1971 as a result of desegregation. It was renamed A.J. Ferrell Middle School of Technology in 1993. It then reopened as Middleton High School on North Twenty-second Street in 2002. (HCPL.)

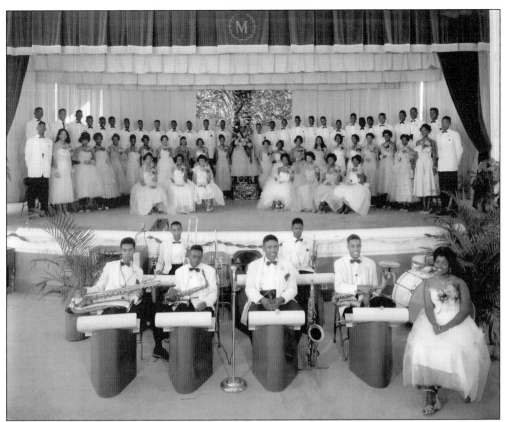

The George S. Middleton High School dance band and the Middleton High School queen's coronation are seen here on October 19, 1954. (HCPL.)

The little boy kneeling on the far left is Billy Reed, who grew up to be "Coach Reed" and a baseball scout for professional baseball. His handprint was encased in stone at the Tampa Bay Rays stadium in St. Petersburg. (Courtesy of Billy and Dorothye Reed.)

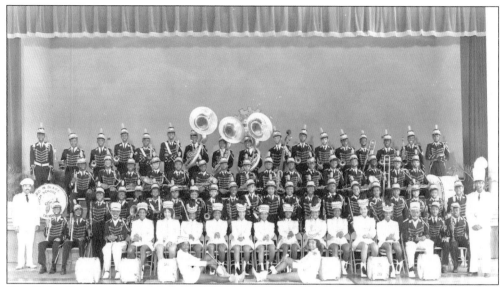

The Blake High School band was a sight to behold in their new uniforms. George Robinson remembers that they were funded by selling gladiolus and candy. In the first row of students sitting in chairs, fifth from the right is Cynthia Flowers. In later years (1990s–2000s), the Blake High School band produced some notable national performers, such as Eric Darius, David Stewart, and B.K. Jackson. (Courtesy of George Robinson.)

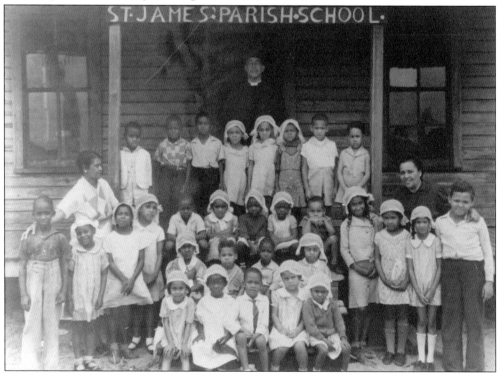

St. James Parish was a day care associated with the Catholic church of the same name. Helen Monroe is sitting in the second row on the far right. In the same row, her brother Herman Monroe is third from the right. (HCPL.)

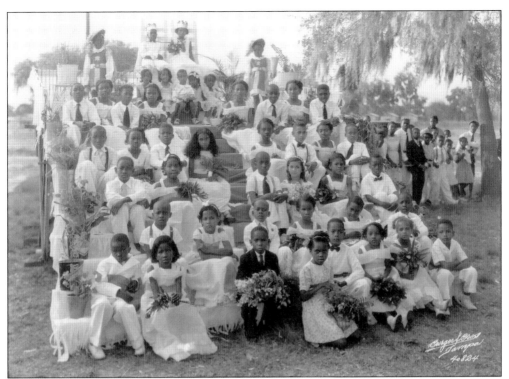

Seated in this beautiful May 3, 1937, "waterfall" of young people are members of the Lomax Elementary School May Day celebration king and queen's court. The queen, Doris Ross, would become the first black female member and chairman of the Hillsborough County School Board. She was also selected as Miss Bethune-Cookman College in 1947. The king was Julius Rose. Fred Hearn's mother, Grace Tillman, is third from the right in the first row. In no particular order, Leona Dickerson, George Bill Adams, and Mary Allen are also among the group. (HCPL.)

A May Day favorite was plaiting the maypole with its multiple vivid colors. It is seen here on the Lomax School grounds, at 4100 Lomax Avenue, in 1935. (HCPL.)

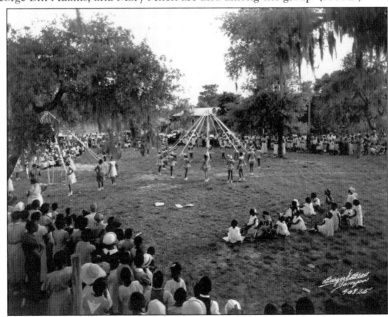

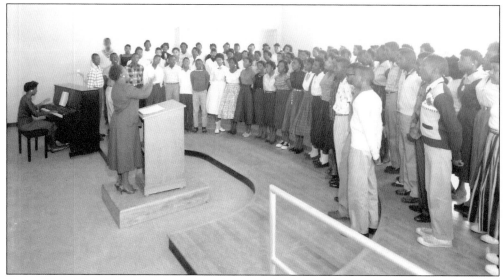

These Blake High School students are rehearsing for a musical presentation. The present-day Blake High School is a performing arts school that has produced Broadway notables such as Danielle Williamson. (HCPL.)

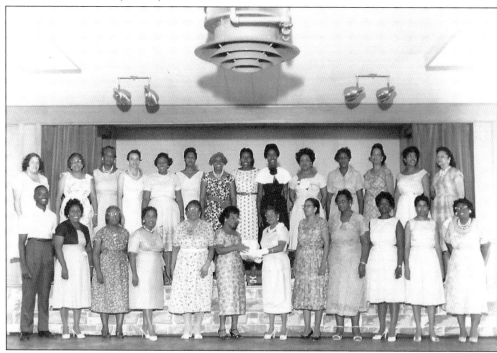

These teachers are attending the pre-desegregation retirement reception for Ella K. Hadley at Lomax Elementary. Shown from left to right are (first row) Ronald Brown, Jennie Larry Webb, Abbie Bendow Clark, Dorothy P. Nelson, Charlette Wells, Georgette Gardner (principal), Ella K. Hadley, Clemmie R. James, Pearl ? , Anthena Brown (music teacher), and Corine Alexander; (second row) Mary L. Daniels, Christine Thomas, Josephine Allen, Floretta ? , Altamese Saunders, Susie K. Maddox, Lois Miles, Willie Mae Evans, Rose Duhart, Masie Evans, unidentified, Gladys Allen, Edith Matae, and Viola Pope. (Courtesy of Doris Ross Reddick.)

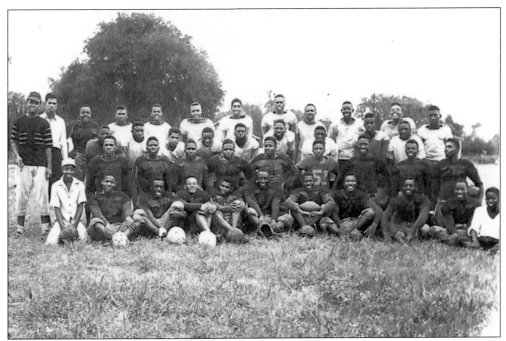

Seen here with his team is coach William O. Bethel. The identified players are (first row) ? Gambrell, ? Hilliard, Joe Green, Israel Tillman Jr., ? Pittman, Billy Reed, Lester Johnson, Frank Johnson, and Albert Jones; (second row) ? Martine, Robert Hammond, ? Goodman, Amos Bozeman, J.D. Allen, ? Cohen, ? Royster, Arthur Mays, Carl Allen, and Earl Washington; (third and fourth rows) trainer Roland Johnson, Rudolph Harris, Willie Paul, Rudolph Harris, Robert Glass, Purcell Houston, Frank Odom, Danny Vickers, Arnold Sullivan, Boisey Waiters, Robert Sutton, Milton Smith, and ? McCauley. (Courtesy of Billy and Dorothye Reed.)

Don Thompson Vocational School, established primarily for African American men returning from military service, offered day and night vocational classes such as blacksmithing, tailoring, auto mechanics, and electroplating. It closed in 1956, and a new school, Howard W. Blake High School, opened, honoring an African American educator by that name. Pictured from left to right are Lee Davis, Mrs. Davis, G.D. Rogers, Mr. Boston, and two unidentified. (HCPL.)

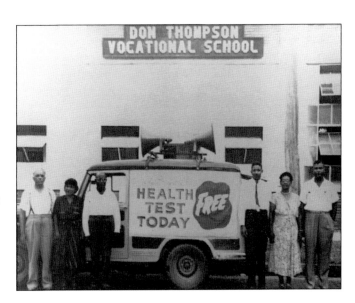

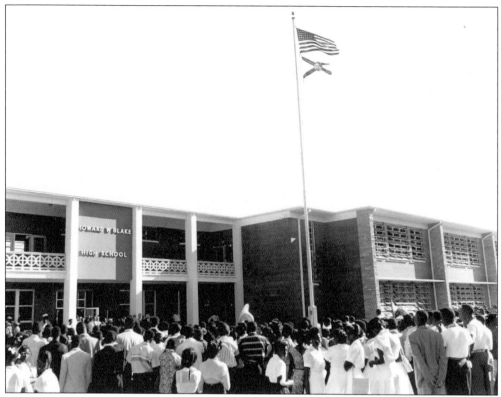

Blake High School's opening dedication ceremony took place in 1956. It is currently a middle school and was later renamed for G.D. Stewart. (HCPL.)

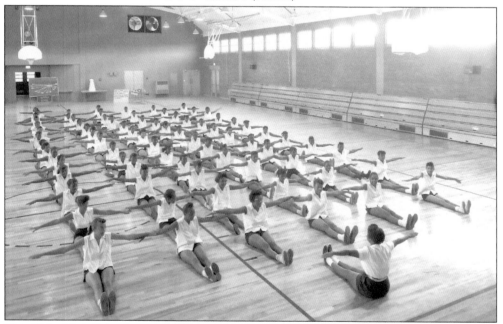

This Blake High School exercise class was a required part of the physical education program in 1956. (HCPL.)

These students are working in a full-function cosmetology class being taught at Blake High School, at 1101 Spruce Street, in 1956. It was known to most as the "Beauty Culture" school. Johnnie Mae Williams ran the program. (HCPL.)

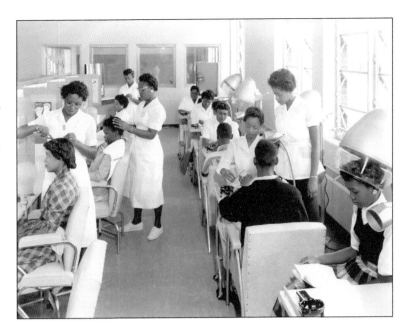

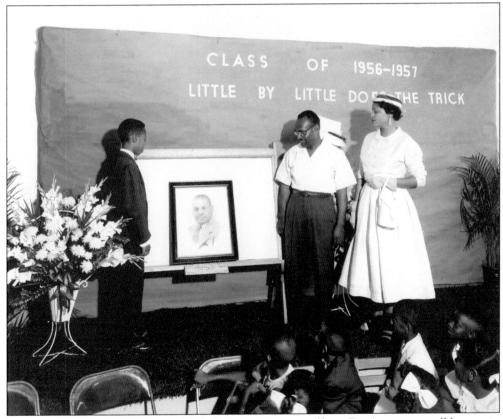

Students honor Dr. Edwin Artest by dedicating a portrait of him. Dr. Artest was well known in the community and is being rewarded for his efforts here. (HCPL.)

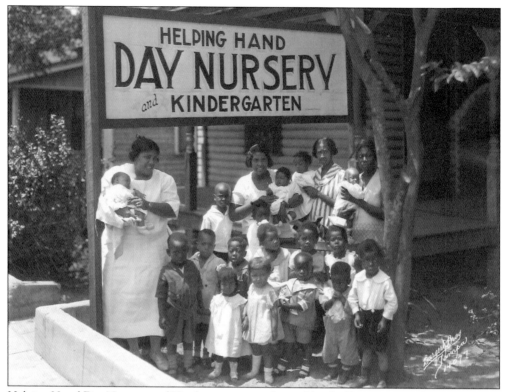

Helping Hand Day Nursery and Kindergarten was planned by the Busy Merrymakers (Industrial Girls) Club of the Tampa Urban League and opened on March 20, 1925, with two trained workers in charge. For 75¢ per week, each child was provided food, weekly medical attention, and a well-equipped playground. Baby welfare classes were also given to mothers. Superintendent Clara Alston is standing on the left. (USF.)

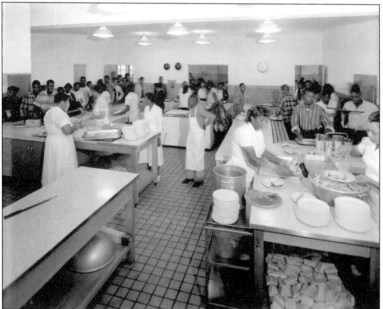

These students are working in the kitchen at Blake High School on November 13, 1956. Home economics classes offered mutual benefit to the school and the student. They learned and they served. (HCPL.)

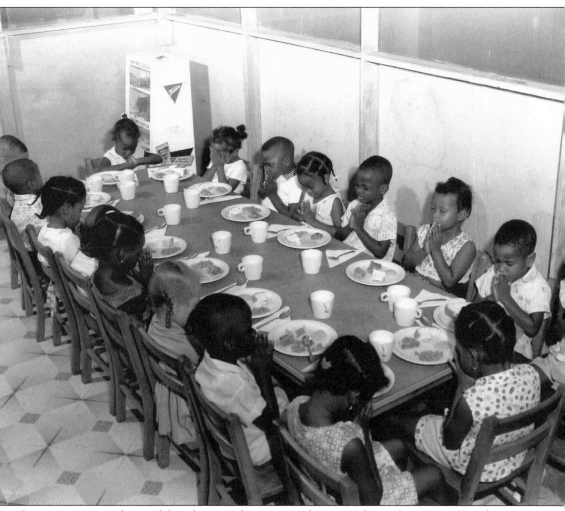

Prayer was a natural part of the educational experience for most African Americans. Two things children were sure to learn were the Lord's Prayer and Grace: "God is good and God is great and we thank him for our food. By his hands, we all are fed. Give us Lord our daily bread. In Jesus' name we pray, Amen." (HCPL.)

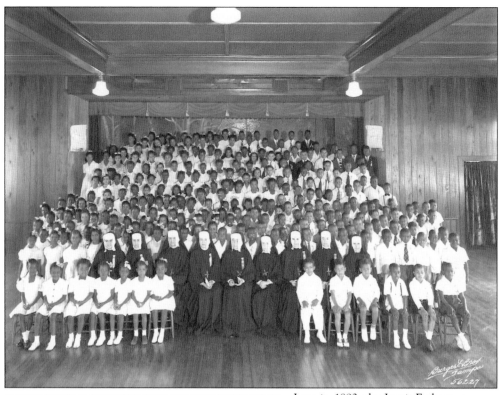

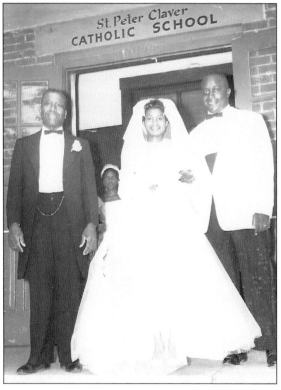

Late in 1893, the Jesuit Fathers at Sacred Heart Church bought property on Morgan Street for the purpose of establishing a school under the name of St. Peter Claver for the children of the African American community. By February 2, 1894, two Sisters of the Holy Names of Jesus and Mary began classes with 16 students. On the night of February 12, 1894, the school building was destroyed by fire, an admitted case of arson. In 1894, Rev. William Tyrell, SJ, with the help of Bishop John Moore, was able to purchase a piece of land and a house on the corner of Scott and Governor Streets in the midst of the African American community. Classes resumed in this temporary structure on October 8, 1894. By the end of the school year, there were approximately 80 students enrolled. Community activities were also held upstairs, including coach Billy and Dorothye Reed's wedding. (Both courtesy of Billy and Dorothye Reed.)

This brother and sister photograph of Osborne and Orzretta Odom shows them dressed for school at St. Peter Claver Catholic School. (Courtesy of Osborne Odom.)

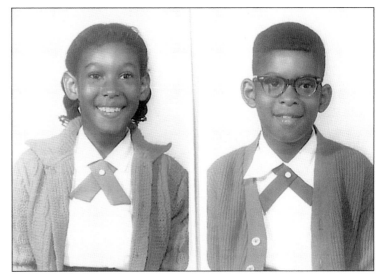

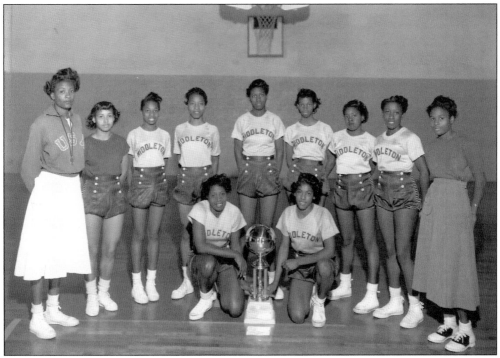

Theresa Manuel is shown on the left wearing her 1948 USA Olympic shirt in this March 17, 1954, photograph. She played basketball at Middleton High School and then led Tuskegee Institute in Alabama to four straight conference track championships. She also set a single-game record in basketball with 57 points while at Tuskegee. She was the AAU indoor champion in the 50-meter hurdles in 1948 and was the first African American from Florida to represent the United States in the Summer Olympics. After college graduation, she coached at Middleton and then Hillsborough High School, and in 1976 she was voted Florida Basketball Coach of the Year. Tampa honored her with a large track meet named for her, the Manuel-Griffin Relays. In 1994, she became the first African American female to be inducted into the Tampa Sports Hall of Fame, and in 2004 the track at Middleton High School was named the Theresa A. Manuel Track and Field. (HCPL.)

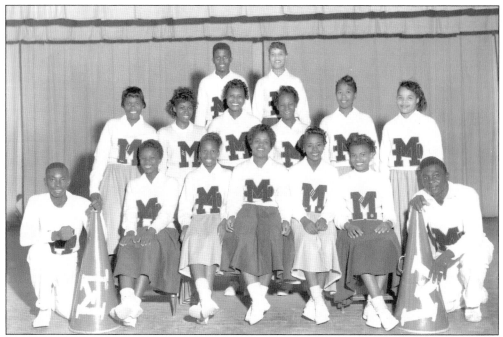

Carolyn Monroe is standing on the far right in the second row in this 1954 photograph of the Middleton High School cheerleading squad. (HCPL.)

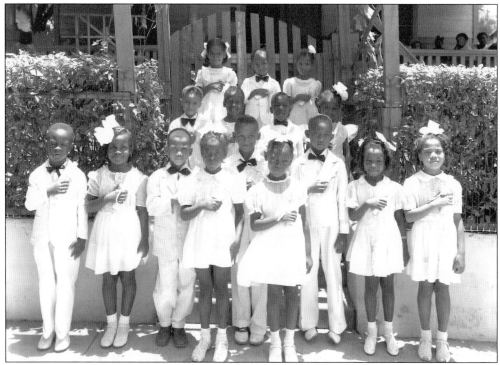

The Helping Hand Day Nursery graduating ceremony is seen here in 1947. Located at 1609 Central Avenue, Helping Hand Day Nursery was highly sought after by Tampa families. This is a prime example of one of the things that made the school so attractive. (HCPL.)

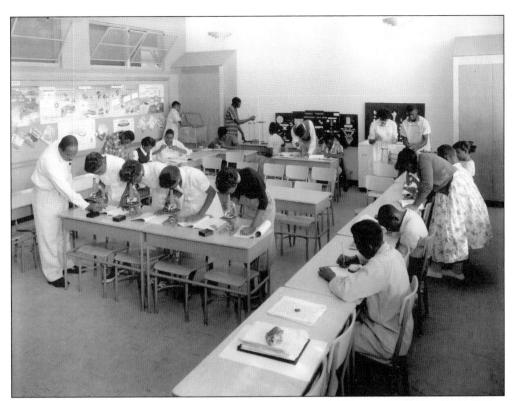

Blake High School provided a well-rounded education. This photograph shows a science class being conducted. (HCPL.)

These beautiful babies were 1946 contest winners at Helping Hands Day Nursery. The child standing on the left is identified only as Regainya, who married a man who worked for Central Life Insurance Company. (HCPL.)

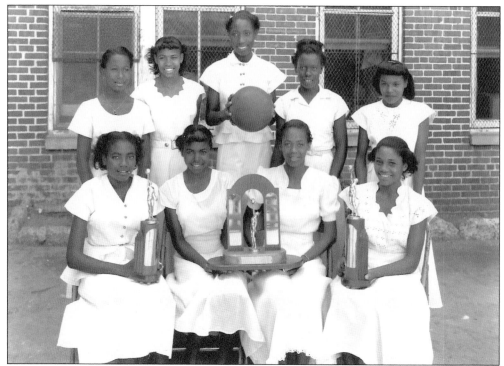

These Booker T. Washington High School young ladies pose with their basketball trophies following the 1949 season. (HCPL.)

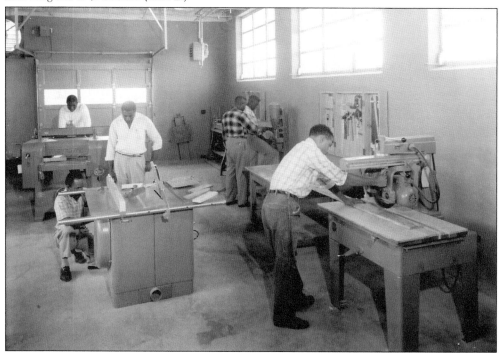

Construction classes, also known as shop class, at Blake High School prepared young men to enter into an industry with a great demand for their services. (HCPL.)

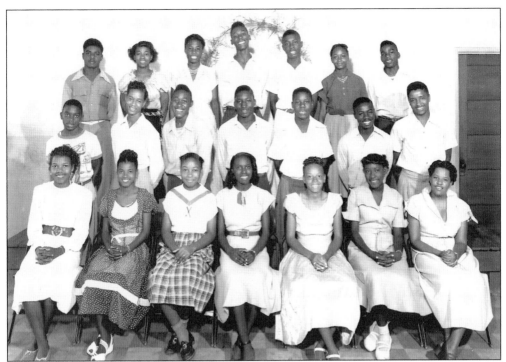

This 1950 photograph of George Washington Carver Junior High School includes Emanuel Cusseaux, who is standing second from the left in the middle row. (HCPL.)

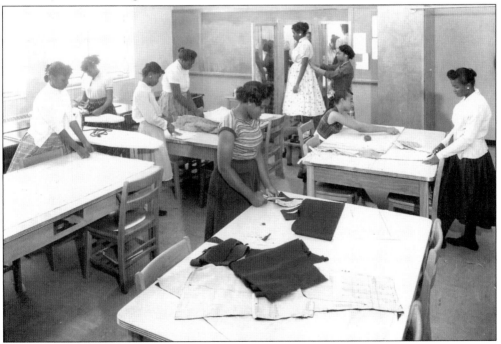

Shown here is a sewing class at Blake High School that prepared young ladies to produce clothing for themselves and others. There were many social events that mandated beautiful attire, and the work of many talented seamstresses was showcased. (HCPL.)

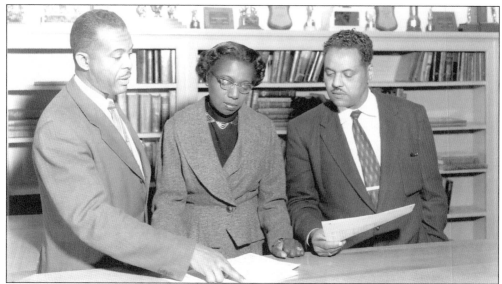

Shown here are Margaret Blake (center) and G.V. Stewart (right). Stewart was the last principal of the old Middleton High School before it closed due to desegregation. Blake and her husband, Howard W. Blake, were educators, leaders, and co-owners of what was known as the "Black service station." She served as a Florida Department of Health specialist and also founded an AKA sorority chapter and was a member of six others. Additionally, she founded a "Pink & Green" club at Booker T. Washington High School. She was the principal of Howard W. Blake High School following Howard's death. (HCPL.)

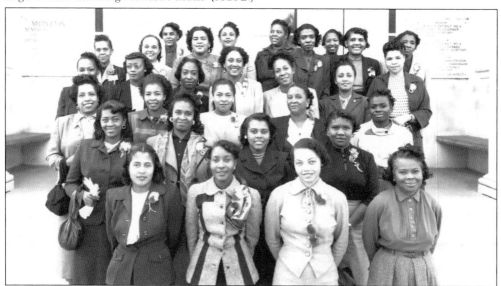

This photograph is of Middleton High School adult advisors. In the first row are, from left to right, unidentified; Edith Raiford; Curtiss Wilson, of Wilson Funeral Home; and unidentified. Fern Thompson is on the far left of the second row. On the far left in the back row is Natalie Smith. Helen Wilson, the first non-nurse African American certified by the American Red Cross in Tampa, is second from the right in the back row. To Helen's right are an unidentified person and then Addie Turner. Addie's sister Hilda Turner was the plaintiff in the successful fight for equal pay for African American teachers. (HCPL.)

On May 12, 1948, a trophy was presented to Principal Andrew J. Ferrell, third from the right, and a group from Booker T. Washington Junior High School. Principal Matthew Esteras is third from the left. (HCPL.)

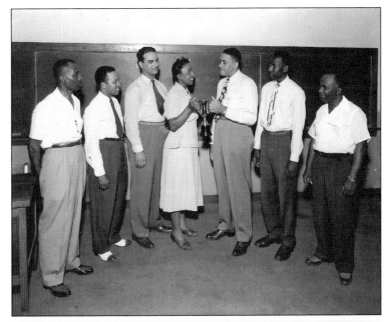

Shown are members of the Hi-Y baseball team from Middleton High School. Identified are (kneeling) Fred Starling (far left), Louis Starling (third from left), Frank Lopez (fifth from left), and Arthur Dunnigan (sixth from left); (second row): Ronnie Brown (third from left), Bobby Thornton (fourth from left), and Louis Jones (sixth from left); (third row) Author "Bronco" Smith (far left) and "Dog Leg" (second from left). (HCPL.)

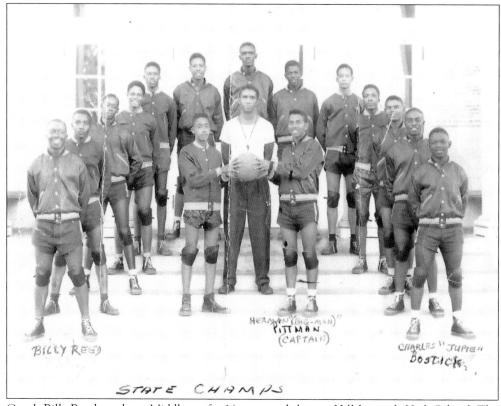

HERMAN "(BIG-MAN)"
PITTMAN
(CAPTAIN)

BILLY REED

CHARLES "JUPIE"
BOSTICK

STATE CHAMPS

Coach Billy Reed taught at Middleton for 14 years and then at Hillsborough High School. The baseball diamond at Hillsborough High School is named in his honor. In addition to those labeled, coach Bill Bethel is standing in the center holding the basketball, Billy Andrews is fourth from the left, James Gatlin is sixth from the left, J.W. Dowling is seventh from the left, and J.D. Ray is second from the right. (Courtesy of Billy and Dorothye Reed.)

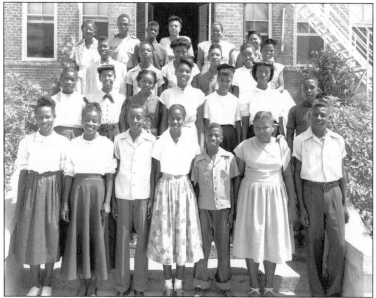

The 1949 George Washington Carver Junior High School's theatre group included "Horse" Wilson, who became a celebrated New York architect and musician. He is in the third row on the far left. (HCPL.)

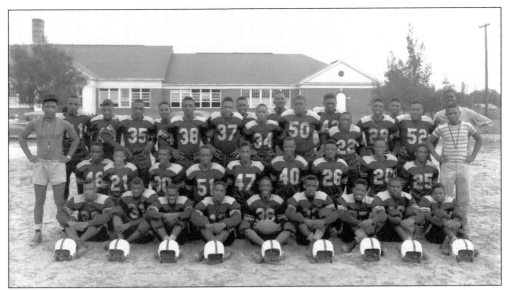

The first person identified in this 1949 photograph of Middleton's football team is "Bubba D," seated on the far left. Third from the right in that row is Freddie "Flat Top" Mitchell, and fourth from the right is Arthur Mays. Coach Bethel is standing on the left, and behind him in the back row is Kelly Williams, who was also an honor student. No. 38 is identified as "Mullet." No. 52 is Frank Mitchell. Coach Bethel and Fred Fuller went to G.V. Stewart together, according to Stewart's son Delano Stewart, for jobs. Bethel was assigned to Middleton, and Fuller was assigned to George Washington Carver. (HCPL.)

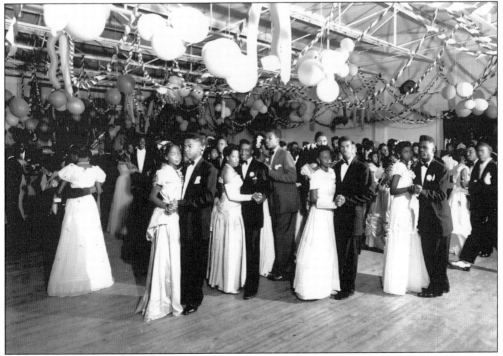

This is what a prom looked like in 1950. Shown here is George Washington Carver Junior High School's prom, held at the recreation center located at 710 Harrison Street. (HCPL.)

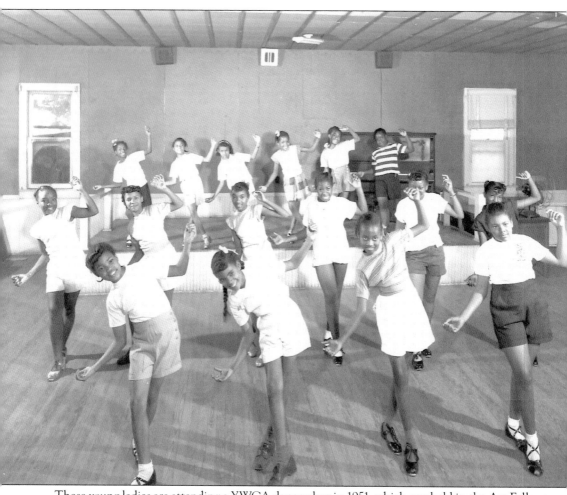

These young ladies are attending a YWCA dance class in 1951, which was held in the Art Fellows Hall. (HCPL.)

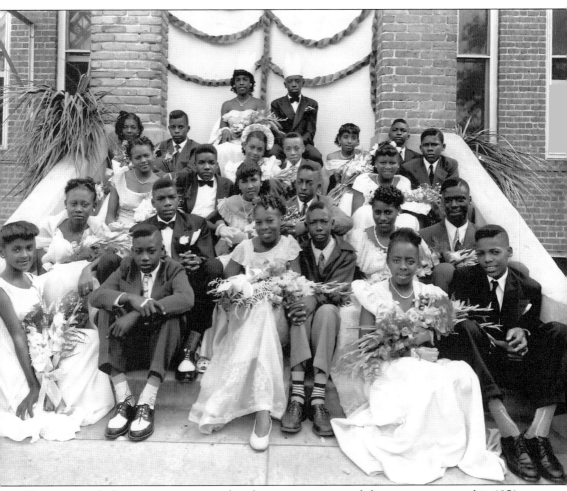

These young ladies are stunning, and a close examination of the young men in this 1951 photograph of George Washington Carver's king and queen's court reveals what the popular haircut was at the time. (HCPL.)

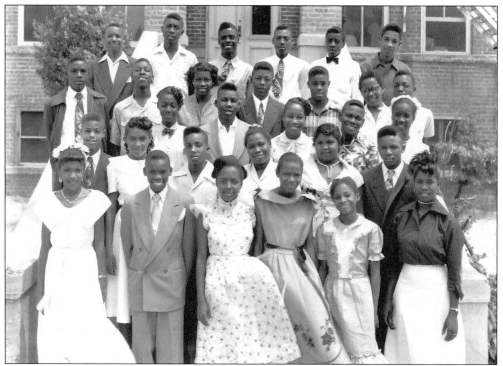

These well-dressed young people are posing for their post-graduation photograph after graduating from George Washington Carver Junior High School in 1951. (HCPL.)

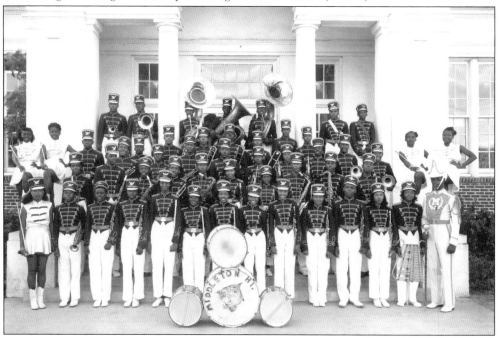

George S. Middleton High School, the first high school for African Americans in Hillsborough County, was known for its well-supported matching band. Maroon and gold were selected in 1934 as the school colors and the Tiger as the mascot. (HCPL.)

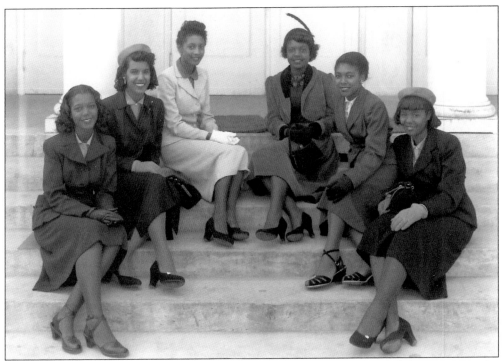

Shirley Lane, shown at the top left in the lighter suit, is among these lovely ladies sitting on the steps of Middleton High School in 1952. (HCPL.)

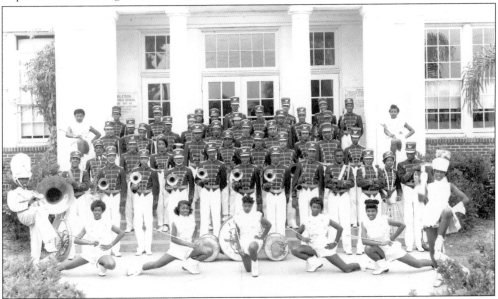

This photograph shows the 1953 Middleton High School band. Two of the majorettes are Ethel Murray (far left) and Irene Ferrell (third from the left). Bobby Bowden is second from the left in the first row. Edward Artest is fifth from the left in the second row, and Delano Stewart is sixth from the left. Deloris Henry (the future Mrs. Alcee Hastings) is eighth from the left. On the far left in the third row is Josephine Brody. Third from the right in the top row is Clarence Young. The majorette at the top right is Grace Jones, Evangeline Best's sister. (HCPL.)

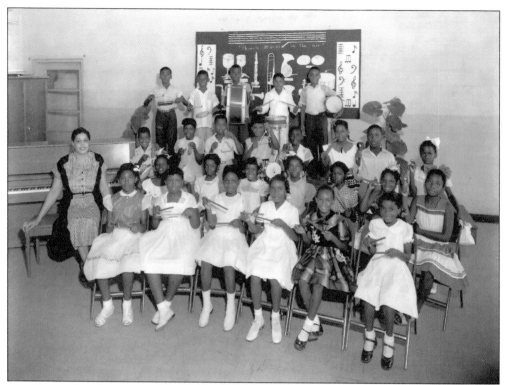

Mrs. Sheehy Henderson is shown here with her 1954 Dunbar Elementary music class. The school was located at 1703 West Union Street. Henderson was Natalie Sheehy's sister. She could be identified because she bears a strong resemblance to her niece Paula Sheehy. (HCPL.)

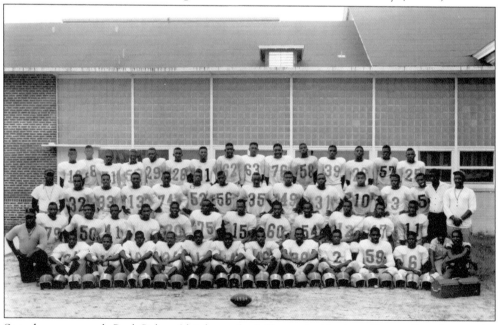

Seen here are coach Paul Culver (third row, far left), coach Abraham Brown (kneeling in the first row), and coach William Bethel (on the far right). (HCPL.)

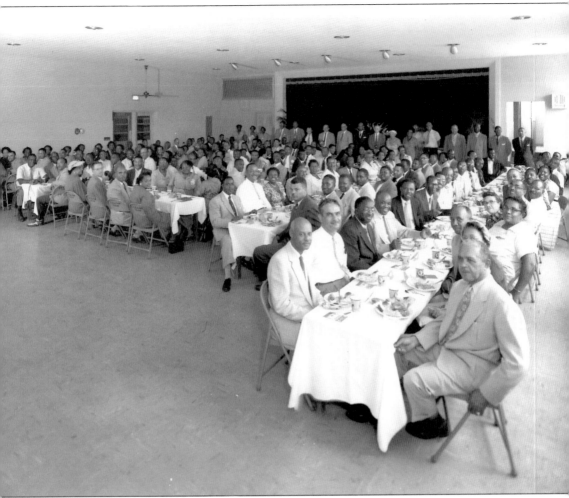

African American principals from Florida public schools are seen here attending a meeting at Christine Meacham Elementary School. Seated on the left side of the first table in the foreground, second from the left, is Matthew Esteras, a Florida A&M High School principal. The fifth person in that row is Dr. Reden Reche Williams Sr., for whom Williams Elementary is named. At the second table, third from the left, is Ethel Jones, who was the principal at Robles Park Elementary and became the first dean of students at Howard W. Blake High School. Also identified, in no particular order, are Dr. Willie Buck Combs, Mrs. Bennett, Ernest Edwards, Mrs. Womack, and G.V. Stewart. (HCPL.)

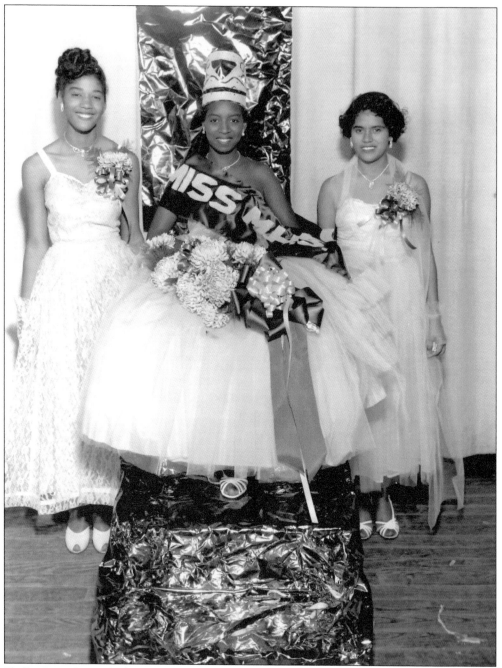

Phyllis Green Lee is the beautiful attendant on the left during this Middleton High School queen's coronation ceremony in the 1953 or 1954 school year. She went on to become principal of Grover Cleveland Elementary School. (HCPL.)

Seen here are dancers and acrobats from Dunbar Elementary in 1955. Y-Teen was part of the YWCA. (HCPL.)

Middleton's very popular math teacher, George "Pappy" Dennis, is pictured here with his graduating homeroom class. (HCPL.)

Standing at the podium is Maxwell Saxon, who is presenting to principals from around the state. Sitting in the first row are, second and third from the left, Minnie J. Fields and Willie "Buck" Combs, who were representing the entire state of Florida. Fields was assigned to all African American elementary schools in Florida, and Mr. Combs was assigned to secondary schools, including those in Tampa. (Courtesy of Harold Clark.)

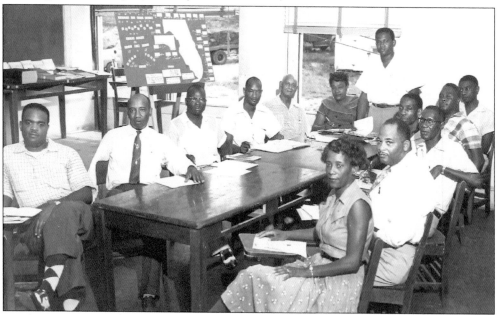

On the far side of the table are, from left to right, Emile Twine, Dr. Leander J. Shaw, Ernest Edwards, unidentified, William Collen Banks, Mildred Bennett, and chairman Harold Clark, who is standing. Sitting on the right, third from the end, is Prince B. Oliver. Sitting in front is Mrs. Womack. During the fall, these principals traveled to Florida Agricultural and Mechanical College (FAMC) to improve competencies. (Courtesy of Harold Clark.)

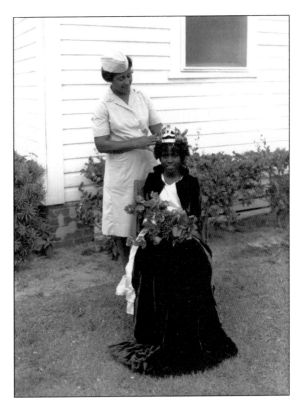

A.L. Lewis was principal of Dobyville School, located at 307 South Dakota Avenue. Shown here are the 1963 queen and king coronation preparation and ceremony. Deborah Larry was crowned queen that year. (Both HCPL.)

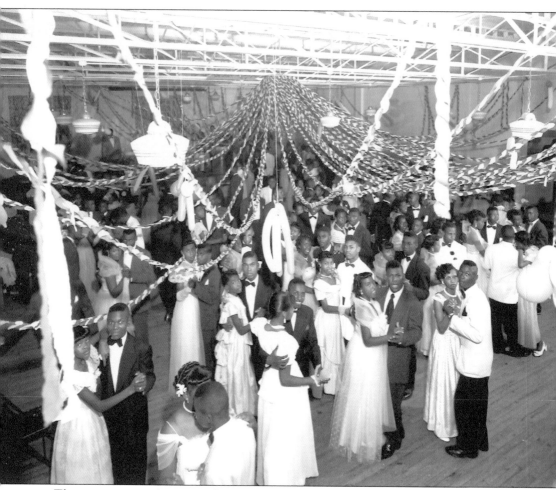

These young people are at their 1952 George Washington Carver Junior High School prom. (HCPL.)

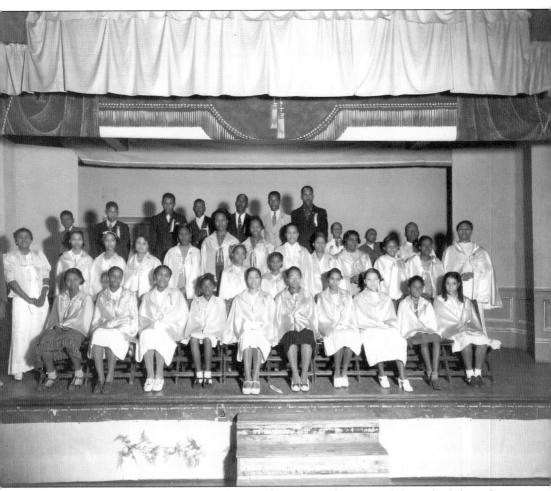

Shown in this 1937 photograph are Faith C. Coleman, standing second from the left in the middle row, and her music students. John and Hattie Ward's daughters were said to have studied with her. (HCPL.)

DISCOVER THOUSANDS OF LOCAL HISTORY BOOKS
FEATURING MILLIONS OF VINTAGE IMAGES

Arcadia Publishing, the leading local history publisher in the United States, is committed to making history accessible and meaningful through publishing books that celebrate and preserve the heritage of America's people and places.

Find more books like this at
www.arcadiapublishing.com

Search for your hometown history, your old stomping grounds, and even your favorite sports team.

Consistent with our mission to preserve history on a local level, this book was printed in South Carolina on American-made paper and manufactured entirely in the United States. Products carrying the accredited Forest Stewardship Council (FSC) label are printed on 100 percent FSC-certified paper.

MADE IN THE USA